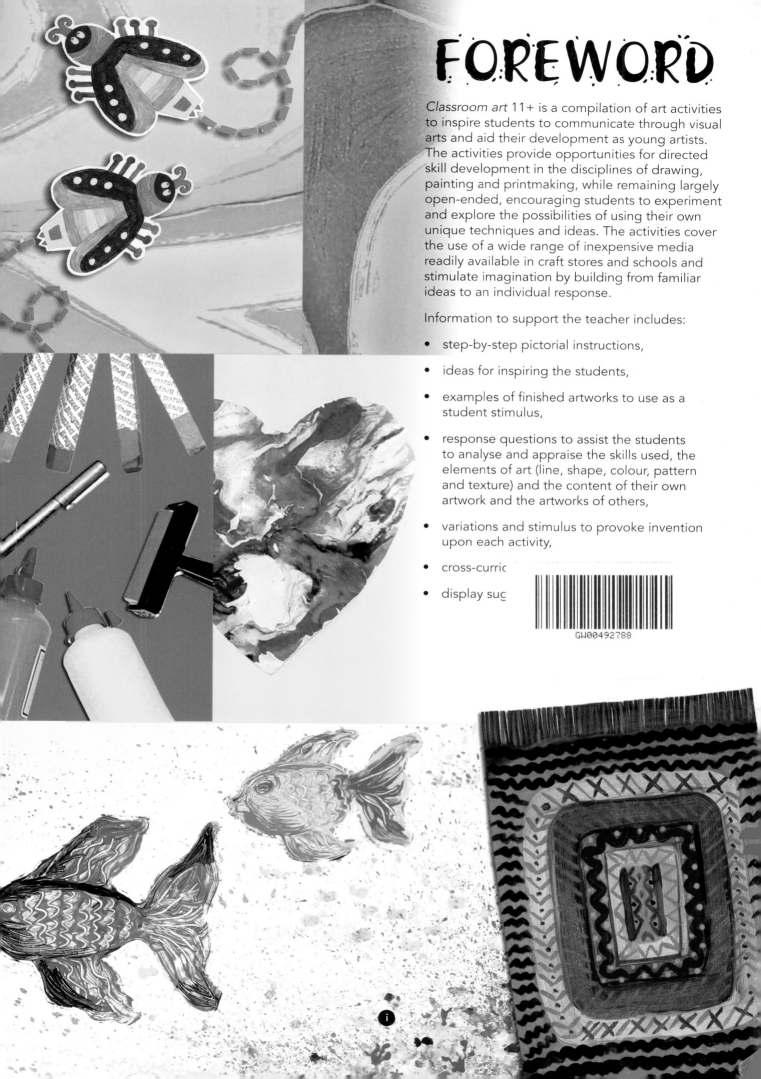

FOREWORD

Classroom art 11+ is a compilation of art activities to inspire students to communicate through visual arts and aid their development as young artists. The activities provide opportunities for directed skill development in the disciplines of drawing, painting and printmaking, while remaining largely open-ended, encouraging students to experiment and explore the possibilities of using their own unique techniques and ideas. The activities cover the use of a wide range of inexpensive media readily available in craft stores and schools and stimulate imagination by building from familiar ideas to an individual response.

Information to support the teacher includes:

- step-by-step pictorial instructions,

- ideas for inspiring the students,

- examples of finished artworks to use as a student stimulus,

- response questions to assist the students to analyse and appraise the skills used, the elements of art (line, shape, colour, pattern and texture) and the content of their own artwork and the artworks of others,

- variations and stimulus to provoke invention upon each activity,

- cross-curric

- display suc

GW00492788

CONTENTS

About this book

DEVELOPING AWARENESS

The activities within *Classroom art 11+* will assist teachers in extracting an artistic response from students. This response will take a variety of forms as the students develop a deepening awareness of art's possibilities.

Art:

- encourages imagination and the ability to solve problems and work within set parameters,

- provides opportunity for lateral and original thought where there are no boundaries dictated by what is 'right' or 'wrong' but simply by what is possible,

- provides a rare vehicle through which we can directly or indirectly communicate and make personal statements about who we are and the life we are living.

To understand and create art, both as a skill and a human response, students need to be aware of the way art is composed. By providing students with a broad cross-section of activities, the teacher will be equipped to introduce and explore each of the 'elements of art' that combine to form visual arts. These elements of art include:

- line,
- shape,
- colour,
- pattern, and
- texture.

Exposure to, and opportunities to exercise these elements, will provide students with the building blocks used by them and other artists to create images, project ideas and illusions, and describe atmosphere or 'tone' within an artwork. By developing artistic awareness in this way, students will be equipped to offer their own response with increased sensitivity.

ENCOURAGING CREATIVITY

In order to encourage creativity, the focus needs to be on individualism. All children make their own art in their own way. Art is one of the only disciplines where we are not required to compete against one another. In fact, the essence of producing art is in acquiring and demonstrating a different personal response – not the 'right' answer. Art is therefore something that everyone should participate in without fear.

However, students are often reluctant to participate in artistic activities for fear of producing substandard work. Because artwork is 'displayed', students may be left feeling exposed by their artwork. It is a good idea to start with more abstract styles to allow the students to build confidence in their ability to combine the elements of art in an informal way. Exposure to postmodern artists and their work can also develop awareness that art is a means of expression through the art elements, colour, shape, line, pattern and texture, rather than a means of replicating an image. Though every artwork a student produces may not 'work', it can be viewed as part of a process towards creating a work that is pleasing. Students need to be aware that sometimes things don't 'look' right, but that their awareness of what looks 'good' demonstrates their artistic ability and can be used to guide future efforts. It is often through these 'mistakes' that new inventive techniques, ideas and effects are born.

After making art, the students should talk about their work and become aware of why they have created it in the way they have. Many students will be content to look at their artwork and the artwork of others purely aesthetically. Encourage them to consider whether they have used their art to tell a story or show how they feel. By considering the purpose of their artwork as a means of sharing something of themselves or what they think or believe, many students can be encouraged to see their own work and the work of others as valuable, and be inspired to reach their true potential.

MODELLING

Students who are told to draw something with no prior practice or information merely repeat the symbols they always draw. Modelling plays an integral role in developing confidence in new artists and providing them with the tools they need to broaden their artistic response. Art does not simply 'explode' onto a page. There are basic skills and techniques involved, just as with any discipline, which require teaching and practice. It is by applying these skills and techniques to new situations and adapting them to suit the needs of the artist, that the individuality and creativity of art can be expressed.

Step-by-step pictorial instructions accompany each of the activities in *Classroom art 11+*. These instructions provide teachers with a simple, logical process to follow and direct their students. A larger photo of a finished artwork has been included as a standard stimulus for the students to aspire to, but not necessarily as a model to copy.

Each artwork in the book aims to develop a different skill or technique or addresses and explores a new concept or style. The purpose of each activity has been described under 'Indications' and should be made clear to the students prior to the lesson and reviewed during the modelling process as a focus for the students to practise and develop.

Step 1

Step 2

Step 3

Step-by-step instructions – 'Lino print icon', pp 58–59.

DEVELOPING SKILLS AND ENCOURAGING PRACTICE

Students love the success experienced by repeating and refining newly-learnt skills. Drawing, painting and printmaking techniques are no exception. It is often during skills based activities that less confident art students will produce their most pleasing work and be inspired to branch out into more expressive ventures.

To be able to draw in different ways, students need to continue to explore drawing media in order to understand and use them for the special effects they wish to achieve. Allow the students time for 'discovery'. In practice sessions, include an element of exploration and an opportunity to develop a personal style. Challenge them with simple problem-solving tasks. For example, how many different types of marks can be made with a single medium? How many more can be created using two media? Can you create marks to represent different textures – spiky, crinkly, swirly, muddy or rough? Can you invent a new colour by mixing paints and what would you name it? What other tools can be used to apply paint? Provide the students with a broad range of media to explore, and apply them to a variety of surfaces. When developing new skills, allow the students plenty of time to create so they can gain skills by looking, sharing ideas and practising.

Often, students will spontaneously create a picture while practising new techniques. These artworks should be valued and used to demonstrate that art is a composition of art elements – not necessarily a recognisable picture. Encourage students to share and discuss these artworks in terms of both content and the skills or techniques they used to create an effect that pleases them.

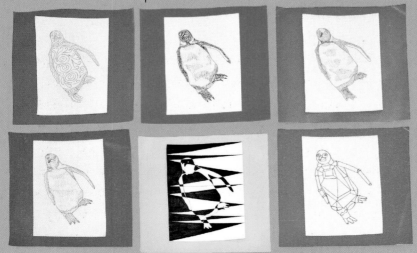

Practising varying techniques – 'Developmental drawing', pp 2–15.

APPRAISING ART

Appraising art is a skill requiring an ability to look at art with personal criteria in mind. In this way, appraisals will vary from one person to another and cannot be assessed as 'right or wrong'. Initially, students will appraise work instinctively, using a 'what looks good' criterion. As they develop an understanding of the elements of art and how they interact to form a balanced image, these too will become part of their criteria. Older students will also address moods, medium, technique appropriateness, content and the artist's purpose in their appraisals. By using these criteria, students will learn to address what kind of art it is, why it has been made, what it is about, what materials or media have been used, and what techniques and art elements have been incorporated. Appraising the work of others – peers, older students, local and famous artists – helps students identify why and how we make art.

It is equally important for the students to appraise their own work in this way and to share their work with others. Encourage the students to focus on what they have done, the materials and tools used, what they have learnt, and what could be done better next time. Address what elements of art are in their work, and why they are or are not happy with their artwork. Be aware, though, that it is also acceptable not to discuss our own work. Sometimes our art is just for us.

CLASSROOM ORGANISATION

The environment in which the students create their artwork needs to be a balance of stimulation and organisation. A room with plenty of stimulus, artworks created by other artists and students, bright colours and elaborate displays, will inspire the students to stretch the boundaries of their ideas. However, a room that is too busy may crowd the students' thinking and prevent them from developing their own ideas, as so many are already on show to choose from. An environment that is neatly presented with stimulating displays is most effective. A well-presented workspace will also encourage the students to take pride in their personal work area and participate more readily in cleaning-up tasks.

Areas used for art can quickly become disaster areas. There should be a designated place for art media, brushes and tools, water containers with broad heavy bases, palettes, paper and cleaning equipment. Ensure the students know these places and are made responsible for their care. In this way, the students will be more particular and conservative with their use of valuable resources.

Ensure the students have their own painting shirt and that there is a ready supply of 'spares' for those that do not have one. A rubbish bag with head and armholes cut out makes an excellent makeshift painting shirt. Always insist upon the students wearing their painting shirts while cleaning up, as this is where most accidental drips and hand prints take place. Before messy art activities, cover the work surface with newspaper, which can be thrown away afterwards, or invest in cheap plastic drop sheets to use as cover-ups. Buckets with damp sponges, dry rags and soda water (for getting paint stains out of carpet and clothing) should also be on hand during messy activities, ready for unexpected spills.

SAFETY

Some art techniques and processes require the use of materials such as bleach and lit candles that may be harmful to the students if used incorrectly.

Many art and craft media are toxic or lead-based and care should be taken when ordering or purchasing art supplies to ensure that they are non-toxic and safe for students.

The most common occurrences of accidents and injury are during the cleaning-up process. Provide a closely monitored, controlled environment in which the students can conduct cleaning tasks safely.

Activities involving materials such as bleach should be undertaken in well-ventilated areas.

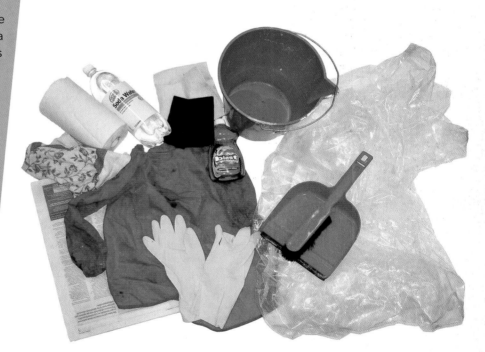

PARENTAL INVOLVEMENT

Art activities involving students can be more successful if adequate adult help is available. Parents are an invaluable part of classroom organisation. Establish a group of willing parents to become regulars with art activities. Orientate them with classroom organisation and clean-up procedures. Allocate a number of students to each adult. Ask helpers to assist in providing and maintaining their group's resources, review instructions with the students and accompany them to designated clean-up tasks. Encourage the parents to create their own art if they would like to, and to model their thought process as they create. Always make a point of showing appreciation for parents who have taken time out to assist you and your students.

ASSESSMENT

Assessment of artworks created by students must be objective and the criteria by which they will be assessed made clear to the students before they create their artwork. Students must also be given the opportunity to reflect upon and discuss their own artwork and the artwork of others in order to demonstrate their understanding of art.

Ideally, assessment of visual arts should be made in four areas,

- ability to identify and discuss art ideas,

- demonstration of art skills, techniques and processes,

- response to visual arts through reflection and evaluation, and

- understanding the role of visual arts in society.

To evaluate a student's understanding and ability as an artist comprehensively, teachers may need to make use of a range of assessment tools, including observations, discussion transcripts and the artworks themselves. An art portfolio can be initiated and built over time to include examples of the student's developing skills, artistic responses and photos of finished pieces. The students will enjoy reflecting upon earlier artworks and monitoring their own development.

DISPLAY IDEAS

Classroom art displays can be used to create an atmosphere to enhance learning and encourage an awareness of how the elements of art, such as colour and pattern, can affect us and reflect the world around us. Clear, vibrant presentation will bring professionalism to the students' work and add value to their art.

Displays can be enhanced using materials in colours that support the artwork. Colours associated with the art's theme, simple frames set against a stark black background, or the use of many shades of one colour to increase vibrancy, are some methods used to enhance an artwork. Positioning the display in a prominent position in the room or using focused lighting will also add effect.

When developing a class display, involve the students in the process. Discuss whether the finished display looks good or how it could be made to look better, how it is positioned and how the art has been spaced, whether the background is appropriate and enhances the artwork, whether the mounts distract the eye from the art, what additions could be made to bring meaning to the art, or what text could be added.

Individual students' work can also be made a focus for display. By incorporating an 'artwork of the week' into the room, students can be encouraged to appraise their own art and learn to listen to others as they discuss their work and ask questions. When selecting a 'picture of the week', discuss why the picture was chosen and put up a sign describing the work and the reasons it was chosen.

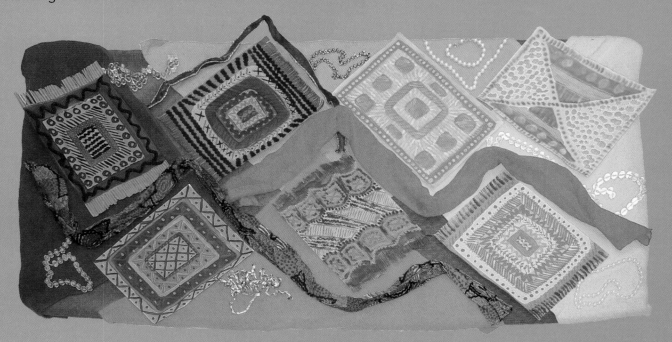

Class display – 'Persian rug', pp 38–39.

UNDERSTANDING THE COLOUR WHEEL

Understanding colours, the effects they can create when placed against each other and how they mix to create new colours, is integral to creating pleasing artwork and displays. The following is an outline of the 'basics' of colour.

Primary colours

– yellow, blue, red.
Primary colours can be mixed to create all other base colours except black and white.

Tints

– adding white
Tints can be created by adding white to any base colour. Tints are commonly referred to as 'pastel' colours. Large quantities of white are required to significantly tint a base colour.

Shades

– adding black
Shades can be created by adding black to any base colour. Small quantities of black paint are required to make a base colour significantly darker.

Secondary colours

– green, orange, purple.
Secondary colours are created when two primary colours are mixed.

red + yellow = orange
yellow + blue = green
blue + red = purple

By adding more of one primary colour than the other, variations of a secondary colour can be made. For example, a small amount of yellow and a large amount of blue will make a blue-green colour. Adding black or white to two primary colours will create tints and shades of secondary colours.

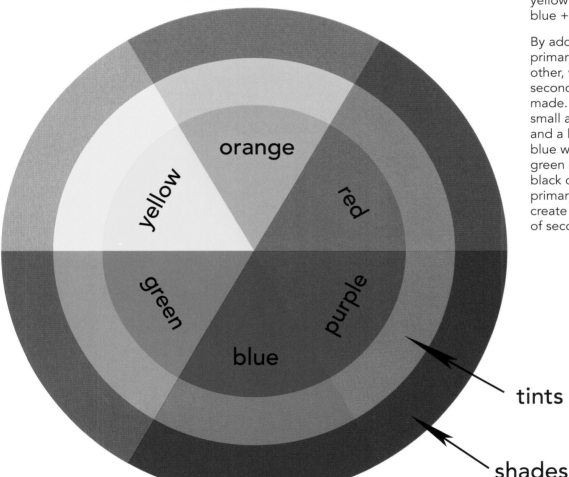

tints

shades

Tertiary colours

are created when any combination of three primary colours is mixed together.

When all three primary colours are mixed, variations of brown can be achieved by adding more or less of each colour. A chocolate brown colour can be made by combining equal parts of red and yellow and a very small amount of blue.

Complementary colours

are those which are opposite on the colour wheel and which stand out strongly when placed against one another. Examples of complementary colours are orange and blue, green and red and purple and yellow.

Analogous colours

Analogous colours describe those that exist side by side on the colour wheel. Artworks in analogous colours are generally composed in variations of two or three colours found side by side on the colour wheel; for example, blue, green and yellow.

RESOURCES

Colour media
lead pencil
coloured pencils
greasy crayons
fluorescent crayons
metallic crayons
felt-tipped pens
marking pens
black fine-tipped pen
acrylic paints
fluorescent paints
powdered tempera paint
edicol powder (dye)
food colouring
pastels

Other resources
magazines
white paper
card for mounting
round object to trace
ruler
eraser
coloured paper squares
scissors
aluminium foil
strong glue
pastel coloured paper
paintbrushes
palettes
newspaper
toothpicks
sand
bleach
cotton buds
paper napkins
sponges
still-life subjects
toothbrush
sheets of card
balloons
string
cutting knife
tray
lithograph paper
textured paper
glitter
liquid starch
lino squares
cutting tools
hard roller
silk screen
squeegee
metal skewer
light card
Blu-Tack®
polystyrene packing beads
sandpaper
corrugated card
bubble wrap
seeds and beans
craft sticks
materials for
making a collage
heavy card
soft roller
clay
wood block
tongs
household items
sea sponge

INDICATIONS

Indications specific to each activity are provided. Each covers one of the following areas:

- skills, techniques and processes, and
- responding, reflecting on and evaluating visual arts.

SEEKING INSPIRATION

We are surrounded by stimuli. Becoming inspired to transform a stimulus into art requires a process by which the stimulus is sparked into an original idea worthy of expressing. This process may take place simply through quiet thought where a mental 'domino effect' will lead a simple stimulus to a different creative level.

However, in a classroom situation, it is often through discussion with others that original ideas are triggered. Therefore, for most art students, discussion is valuable and should not be discouraged.

Students should be encouraged to discuss why the pictures we draw or paint are different from photographs, and to compare illustration styles, and the difference between real and abstract pictures. Students should also be encouraged to attempt to replicate the techniques used by other artists, watch artists work and to discuss art with artists themselves.

Teachers should expose the students to artworks that they are enthusiastic about themselves, and demonstrate a broad selection of styles and periods. This will provide discussion opportunities relating to specific artists, styles or movements, content, media and art elements, all of which provide key material from which students can develop interest and artistic direction.

Discussion, personal experiences and exposure to collections of art stimuli relating to a particular theme or style will provide a range of ideas for students to mesh into a new and unique idea for their own artwork.

Collections may include artworks or displays from other classrooms, prints, pictures in books, photographs, tools and media, photos, magazine articles, posters, artefacts, everyday objects, journal entries, poems, and other artists' work.

Each activity within *Classroom art 11+* is prefaced by a list of ideas that can be used to inspire student interest in readiness for the activity.

INSTRUCTIONS

Specific four-step instructions are given for each activity, with accompanying photographs.

REFLECTION QUESTIONS encourage students to evaluate the skills, techniques and processes used and extend students' thoughts concerning the use of the technique or subject in order to appraise their art.

VARIATIONS

When students are using new techniques or responding to a new stimulus, there will always be opportunities for numerous variations on a theme. These variation activities will allow students to consolidate what they have learnt and will also demonstrate how a technique, idea or style can be altered to produce a different response. Students will often spontaneously see an opportunity for producing something unique from an activity, either prior to commencing or during the process of creating an artwork. Teachers should always allow the students to deviate and develop their creative response. There will be time for specific skill development later. Though technique is important, creativity should always take priority.

A list of suggested variations supplements each of the activities in *Classroom art 11+*.

ACROSS THE CURRICULUM

Art is a wonderful means of expressing new discoveries and personal interests. Students learning new material in other curriculum areas will find art a stimulating means of expressing their new knowledge. Immersion within a theme or topic will provide ample stimulus for new and creative artwork. Although there is merit in teaching art in isolation for 'art's sake', in a classroom situation, student involvement in other areas of the curriculum can be utilised to form a foundation for original art ideas.

Each activity in *Classroom art* 11+ is accompanied by a list of suggested cross-curricular activities. These activities can be used to consolidate or complement learning in art lessons.

RECIPES FOR MEDIA

Liquid starch – Dissolve starch powder in a small amount of cold water to make a paste. Add boiling water, stirring continuously until the mixture becomes opaque and of the desired consistency. Create a thinner consistency for paint or a thicker consistency for use as a glue.

Liquid starch is suitable for gluing paper, sticks to metal, glass, waxed paper and plastic, and dries clear. Add edicol dye or powdered tempera paint to liquid starch to create a thicker, slightly translucent paint ideal for finger painting. Adding liquid starch to paint is an economical way to increase paint supplies and will keep for long periods in airtight containers in the refrigerator.

Cornflour paste – Use two tablespoons of cornflour to one cup of water. Mix enough water with the cornflour to make a paste. Add the remaining water and bring to the boil. Continue to stir until a custard-like consistency is achieved. Add water if a thinner consistency is preferred. Mix powdered tempera paints or edicol dye with a small amount of water and add to the mixture when cool.

Cornflour paste is suitable for gluing paper or for adding to edicol or powdered paint.

Edicol paint – Dissolve about 1/8 of a teaspoon of edicol dye powder in a tablespoon of water and add to cornflour paste, commercially available wallpaper paste or liquid starch to create thick translucent paint in brilliant colours. Add detergent to the mixture to assist in adhesion to glass, plastics and foil. Mix edicol powder with small amounts of water to create vivid dyes for use on fabric or paper. Food colouring can be used as an inexpensive, but less vivid, substitute for edicol dye.

Powdered tempera paint – Dissolve a teaspoon of powdered tempera paint in a small amount of water to make a paste. Add to cornflour paste, commercially available wallpaper paste or liquid starch to create a thick, opaque paint suitable for covering patterned surfaces, such as lettering on boxes.

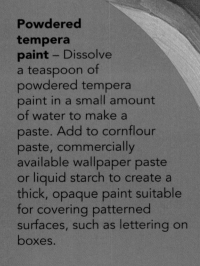

Soap paint – Pour two cups of warm water into a bowl. Using an electric mixer, begin mixing, adding soap flakes gradually. Beat until the soap forms soft peaks. Add colouring to the soap and mix through.

Powdered tempera paint, edicol paint or acrylic paint can be used to colour soap paint successfully.

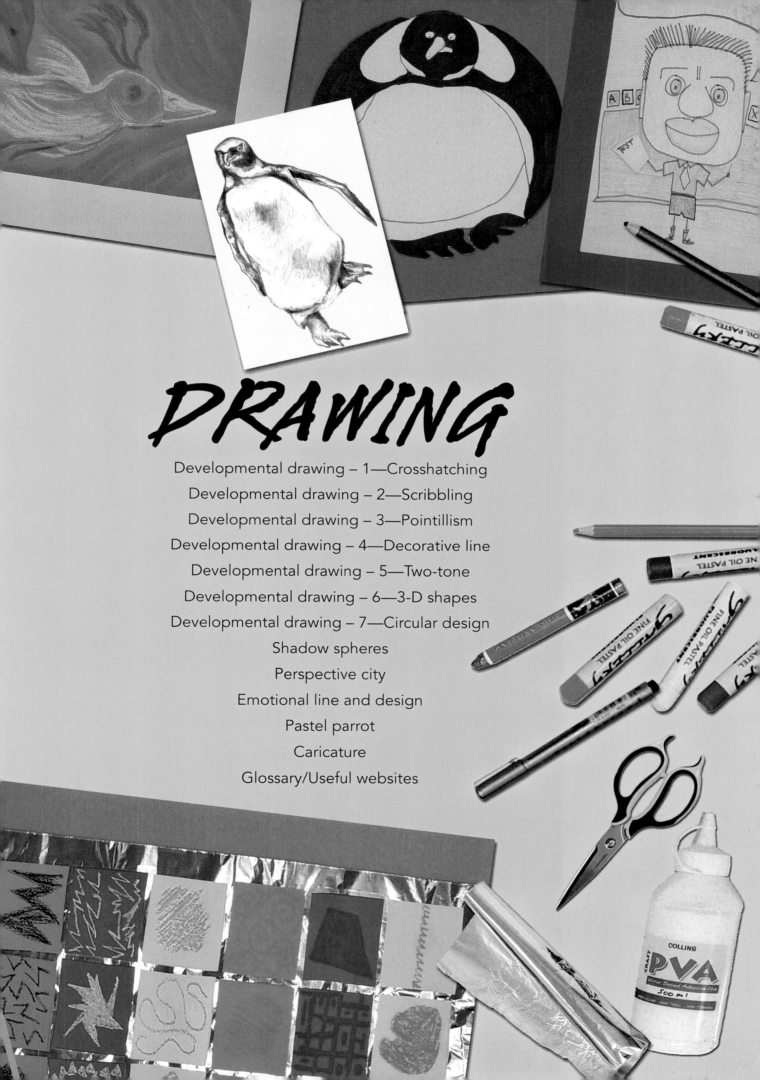

DRAWING

Indications:

Skills, techniques, technologies and processes

- Uses crosshatching to create shading of different weights.
- Uses crosshatching to describe the shadows on a three-dimensional image.

Responding, reflecting on and evaluating visual arts

- Appreciates that crosshatching is a means by which shadows can be described.
- Enjoys giving depths to two-dimensional shapes by crosshatching.

Inspiration

- Show artworks where hatching has been used.
- Demonstrate how lines and hatches of ranging density can give an illusion of lighter and darker shading.
- Students experiment with this technique.

Resources

- picture to copy
- white paper (A5)
- lead pencil
- black fine-tipped pen
- card for mounting

Instructions

Step 1

Find a picture of a subject that has distinct dark and light areas; for example, a penguin. The picture could be from a magazine, a photocopy of a picture from a book or printed from the Internet.

Copy the picture onto a separate sheet of paper.

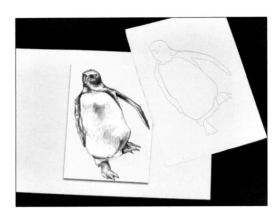

Step 2

Shade in the darker areas and shadows using faint, parallel lines all in one direction. Where the areas are darkest, the lines should be closest together, where lightest, the lines should be furthest apart.

Hatch the lines in the darker areas by drawing lines in the opposite direction to create crosses. Again, these lines should be parallel and closer or further apart, depending on how dark the area should be. Some areas of the picture should be left white. Using this technique, there should be no shading. Rather, all shading should be achieved through crosshatching lines.

Step 3

Use a fine-tipped black pen to trace over the crosshatching to create a more defined drawing.

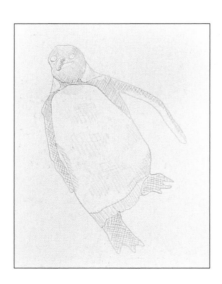

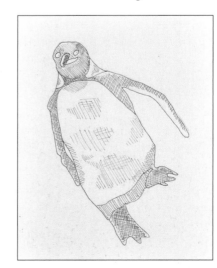

Crosshatching

Step 4

Mount on a conservative colour (burnt orange, navy blue, olive green, maroon) and then onto black. Encourage the students to complete other developmental drawing activities and to produce a personal portfolio of 'technique' drawings using the same subject. The completed drawings could be displayed as a series, using a long single mount.

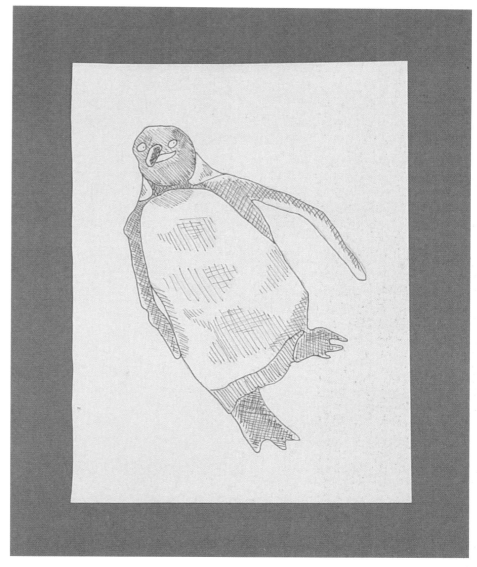

Reflection questions

- How did you achieve lighter and darker shading?
- What drawing media would be most effective for crosshatching?
- Is your picture still clear using this technique?
- Did you choose a good subject to use this technique with?

Variations

- Repeat the activity, using a different coloured pen.
- Explore this shading technique to describe a still life such as a portrait or a leaf.
- Encourage the students to use line to describe or give a picture direction. For example, have them draw a windblown crop using lines and hatching.

Cross-curricular activities

- Write short stories, a description, or research information about the subject chosen to draw. Display with the developmental drawing.
- Draw line graphs to track and compare temperatures in different parts of the country.
- Design and construct simple objects or boxes using toothpicks or craft sticks and strong glue.
- Look at the way furniture is constructed using support beams which cross a structure to increase its strength.

Resources
- picture to copy
- white paper (A5)
- lead pencil
- black fine-tipped pen
- card for mounting

Indications:

Skills, techniques, technologies and processes

- Uses scribbling to shade an object.
- Uses scribbling to describe shadows on a three-dimensional image.

Responding, reflecting on and evaluating visual arts

- Appreciates that scribbling is a means by which shadows can be described.
- Enjoys giving depth to two-dimensional shapes using a scribbling technique.

Inspiration

- Show artworks where scribbling has been used.
- Demonstrate how scribbling lines of ranging density can give an illusion of lighter and darker shading.
- Students experiment with this technique.

Instructions

Step 1

Find a picture of a subject that has distinct dark and light areas; for example, a penguin. The picture could be from a magazine, a photocopy of a picture from a book or printed from the Internet.

Copy the picture onto a separate sheet of paper.

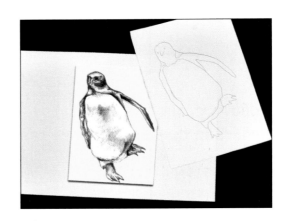

Step 2

Shade in the darker areas and shadows using faint, random, scribbling. Where the areas are darkest, the scribbles should be tightest, where lightest, the scribbles should be looser and more open. Some areas of the picture should be left white. Using this technique, there should be no shading. Rather, all shading should be achieved with scribbling.

Step 3

Use a fine-tipped black pen to trace over the lines to create a more defined drawing.

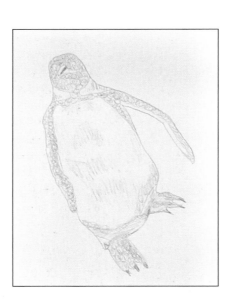

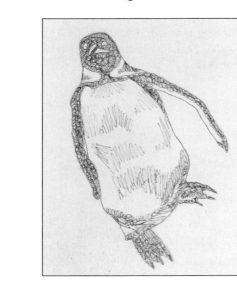

Scribbling

Step 4

Mount on a conservative colour (burnt orange, navy blue, olive green, maroon) and then onto black. Encourage the students to complete other developmental drawing activities and to produce a personal portfolio of 'technique' drawings using the same subject. The completed drawings could be displayed as a series, using a long single mount.

Reflection questions

- How did you achieve lighter and darker shading?
- What drawing media would be most effective for scribbling?
- Is your picture still clear using this technique?
- Did you choose a good subject to use this technique with?
- Does your scribbling look messy from a distance? What impression does it give?

Variations

- Repeat the activity, using a different coloured pen.
- Explore this shading technique to describe a still life such as a portrait or a leaf.
- Encourage the students to use scribbling to describe textures in a picture. For example, variations in the texture of an animal's body covering.

Cross-curricular activities

- Investigate insects that leave marks resembling scribbly lines in trees. Search the local natural environment for evidence of their presence.
- Brainstorm to list other creatures which leave trails in irregular and regular patterns; e.g. snails, crabs or snakes.
- Experiment with different types of scripts for decorating and titling work.
- Evaluate personal handwriting and make adjustments and improvements.

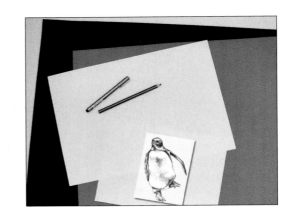

Resources

- picture to copy
- white paper (A5)
- lead pencil
- black fine-tipped pen
- card for mounting

Indications:

Skills, techniques, technologies and processes

- Uses dots at various proximities to each other to create shading.
- Shades using dots to produce depth and dimension on a flat image.

Responding, reflecting on and evaluating visual arts

- Appreciates that using dots at different proximities to each other can cause different depths of shading and create dimension.
- Enjoys experimenting with unusual shading techniques.

Inspiration

- Look at artworks such as *Sunday Afternoon on the Island of La Grande Jatte* by Seurat (1884) where only dots have been used to describe an image.
- Students experiment placing dots close together and spread apart to create different shading effects.

Instructions

Step 1

Find a picture of a subject that has distinct dark and light areas; for example, a penguin. The picture could be from a magazine, a photocopy of a picture from a book or printed from the Internet.

Copy the picture onto a separate sheet of paper.

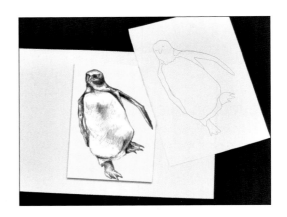

Step 2

Use light pencil dots to shade the darker areas of the picture. Increase the number of dots in the darkest areas and dot sparsely in lighter areas. Continue to build up layers of dots to achieve a strong contrast between the darkest and lightest shaded areas. Some areas of the picture should be left white. Using this technique, there should be no shading. Rather, all shading should be achieved through dots.

Step 3

Use a fine-tipped black pen to trace over the dots to create a more defined drawing.

Pointillism

Step 4

Mount on a conservative colour (burnt orange, navy blue, olive green, maroon) and then onto black. Encourage the students to complete other developmental drawing activities and to produce a personal portfolio of 'technique' drawings using the same subject. The completed drawings could be displayed as a series, using a long single mount.

Reflection questions

- How did you achieve lighter and darker areas using pointillism?
- Is your picture still clear using pointillism?
- Did you choose a good subject to use this technique with?
- Do you think dots look as effective as shading?
- Can you think of any situation where using dots as a means of shading would not be effective?

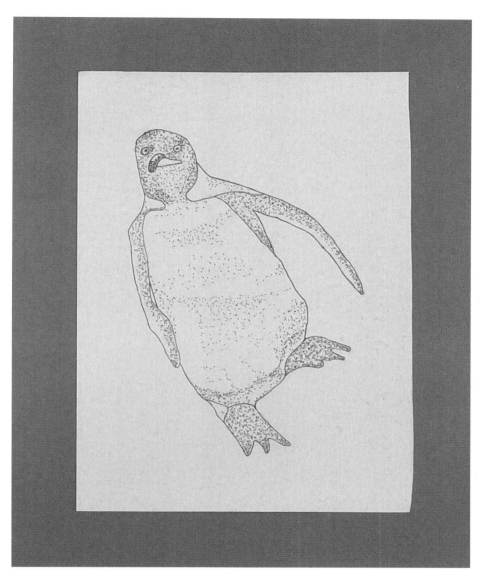

Variations

- Repeat the activity, using a different coloured pen.
- Allow the students to apply the pointillism technique to a landscape, using coloured pencils.
- Use coloured felt-tipped pens to attempt to create an image with dots, where no white background is left.

Cross-curricular activities

- Use dot paper to construct two-dimensional and three-dimensional shapes.
- Use dot paper to assist in drawing larger scale three-dimensional drawings.
- Use dot patterns in arrays to investigate square and triangular numbers.

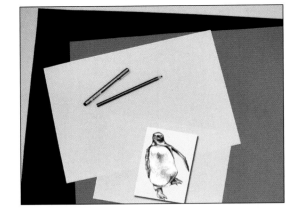

Indications:

Skills, techniques, technologies and processes

- Uses decorative line to give a flat image a particular style.

Responding, reflecting on and evaluating visual arts

- Understands that different types of decorative lines represent different styles.
- Enjoys using decorative lines to bring life and style to a flat surface.

Inspiration

- Discuss where decorative lines are used (Christmas decorations, cards, packaging, fabrics).
- Allow the students to pattern and decorate using flowing lines.
- Look at fairytale books and pictures of decorated cakes, and note the types of decorative lines and patterns used.

Resources

- picture to copy
- white paper (A5)
- lead pencil
- black fine-tipped pen
- card for mounting

Instructions

Step 1

Find a picture of a subject that has distinct dark and light areas; for example, a penguin. The picture could be from a magazine, a photocopy of a picture from a book or printed from the Internet.

Copy the picture onto a separate sheet of paper.

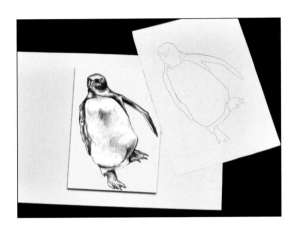

Step 2

Consider the style of the subject. Is it 'flowery', 'flowing', 'hard', 'angled', 'frightened', 'scary'? What kind of line would best describe the style of the subject? Allow the students to experiment with different styles of lines and to develop one that suits their subject.

Decorate the subject using lines in the chosen style. Darker areas can be created by drawing the decorative lines closer together. In this activity, the emphasis is upon creating a personality for the subject through the style of line used. The subject should be covered completely with decorative lines, rather than leaving areas of white.

Step 3

Use a fine-tipped black pen to trace over the lines to create a more defined drawing.

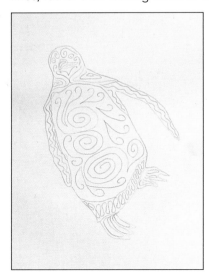

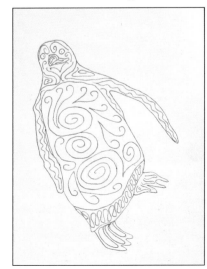

Decorative line

Step 4

Mount on a conservative colour (burnt orange, navy blue, olive green, maroon) and then onto black. Encourage the students to complete other developmental drawing activities and to produce a personal portfolio of 'technique' drawings using the same subject. The completed drawings could be displayed as a series, using a long single mount.

Reflection questions

- How would you describe the decorative lines you drew? Flowing? Rigid? Both?
- Why did you draw these types of lines? Do they suit the subject matter?
- Did your decorative lines turn out the way you expected? Do they look effective? Messy?
- Could you have drawn the lines differently inside the shape with better results?
- Are you satisfied with your work?

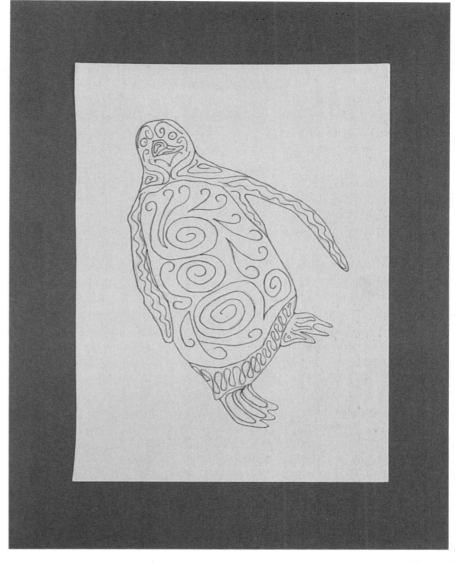

Variations

- Repeat the activity, using a different coloured pen.
- Use decorative lines to write names to label books.
- Use colourful pens to draw decorative lines as borders on greeting cards, or to make wrapping paper.
- Write short stories and decorate a book cover using lines that describe the type of story; e.g. scary, sad or exciting.

Cross-curricular activities

- Research the national costumes of other countries and how their decorations are unique to, and representative of, their countries.
- Investigate traditional decorations used in various celebrations around the world.
- Compare the decorations used by different cultures during different periods of history. Look at fabric designs, furniture and artwork.
- Investigate traditional face painting in different cultures' and their significance.

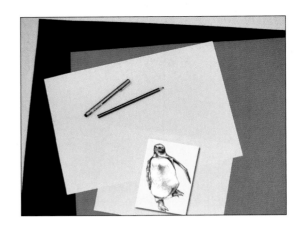

Indications:

Skills, techniques, technologies and processes

- Divides a drawing into random sections using a ruler.
- Selects the appropriate shapes to colour to create a two-tone effect where no two coloured sections are adjacent.

Responding, reflecting on and evaluating visual arts

- Reflects upon how a negative/positive image could be created using a single colour.
- Understands that an image can be revealed using a combination of abstract shapes.

Inspiration

- Investigate colours which are complementary (opposite on the colour wheel).
- Look at single colour prints such as icons or logos.
- Draw a checkerboard in which alternative colours are used to draw pictures in each square (black on white or white on black)
- Look at silhouette pictures where blackened areas describe a horizon or picture.

Resources

- picture to copy
- white paper (A5)
- lead pencil
- black fine-tipped pen
- card for mounting

Instructions

Step 1

Find a picture of a subject that has distinct dark and light areas; for example, a penguin. The picture could be from a magazine, a photocopy of a picture from a book or printed from the Internet.

Copy the picture onto a separate sheet of paper.

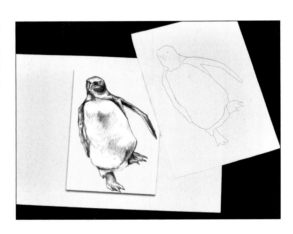

Step 3

Use a fine-tipped black pen to trace the subject's outline and the zig-zagged line. Use a pencil to colour the picture so that there are no coloured areas adjacent. Think carefully about which areas will be coloured and move in a single direction (left to right or top to bottom) rather than colouring randomly, to reduce the chance of making errors.

Step 2

Draw lines in pencil across the width of the drawing to create an irregular zig-zag from edge to edge.

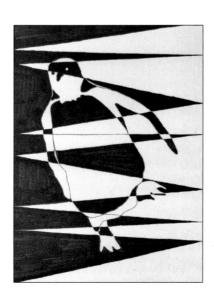

Two-tone

Step 4

Mount on a conservative colour (burnt orange, navy blue, olive green, maroon) and then onto black. Encourage the students to complete other developmental drawing activities and to produce a personal portfolio of 'technique' drawings using the same subject. The completed drawings could be displayed as a series, using a long single mount.

Reflection questions

- Did you have any difficulties deciding which areas to colour and which to leave blank? How did you go about making sure you did not make any errors?
- When complete, was your image still easily recognisable?
- How else could you have drawn partition lines to create a two-tone picture?

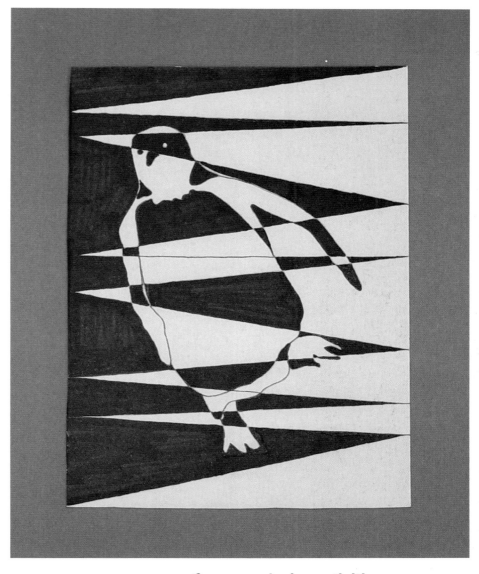

Variations

- Draw vertical zig-zag partition lines, squiggly partition lines or create a checkerboard pattern for two-tone colouring.
- Use two colours or black and one bright colour as the 'two tones' for colouring.
- Cut a shape from coloured paper and mount both the shape and the cutaway to create a negative/positive image.

Cross-curricular activities

- Create symmetrical patterns by measuring and drawing or ruling lines.
- Learn the rules of chess and conduct class or school tournaments.
- Investigate the probability of rolling odd or even numbers or selecting one of a number of coloured counters from a bag.
- Learn about the companies and organisations represented by certain logos; for example, Unicef or World Vision.

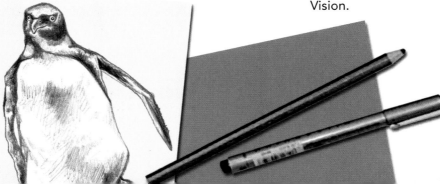

Indications:

Skills, techniques, technologies and processes

- Draws three-dimensional shapes in abstract form to describe the features of an object or creature.

Responding, reflecting on and evaluating visual arts

- Appreciates that dimension can be built from a series of three-dimensional shapes.
- Understands that all objects can be broken down into three-dimensional shapes.

Inspiration

- Draw simple 3-D shapes close together to create a conglomerate of shapes. Stress that it is unnecessary for all the shapes to share the same perspective for this activity.
- Construct people or creatures using a variety of building block shapes.

Resources
- picture to copy
- white paper (A5)
- lead pencil
- black fine-tipped pen
- card for mounting

Instructions

Step 1

Find a picture of a subject that has distinct dark and light areas; for example, a penguin. The picture could be from a magazine, a photocopy of a picture from a book or printed from the Internet.

Copy the picture onto a separate sheet of paper.

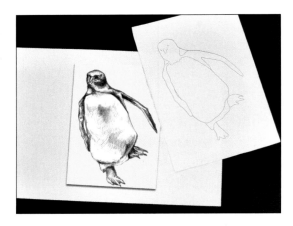

Step 2

Imagine the subject in its three-dimensional form. What areas would be most prominent? What three-dimensional shape would these areas most resemble? Try to imagine the subject broken into many small three-dimensional shapes. Encourage the students to base the shapes they use on the image they see rather than what they know. For example, they may think that their subject's head is a sphere, but on closer observation discover that it is made up of a hemisphere and a pyramid snout.

Draw the subject within the confines of the copy using only three-dimensional shapes.

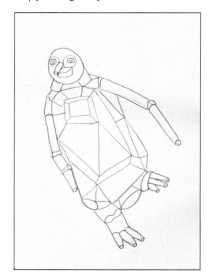

Step 3

Use a fine-tipped black pen to trace over the three-dimensional shapes and create a more defined drawing. If desired, crosshatching can be added to create shading on some faces of the shapes to give them depth.

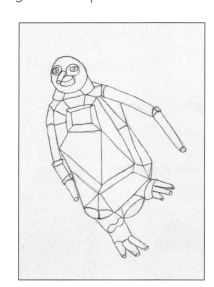

3-D shapes

Step 4

Mount on a conservative colour (burnt orange, navy blue, olive green, maroon) and then onto black. Encourage the students to complete other developmental drawing activities and to produce a personal portfolio of 'technique' drawings using the same subject. The completed drawings could be displayed as a series, using a long single mount.

Reflection questions

- How would you describe the final appearance of your 3-D drawing?
- Could you have chosen other shapes to describe various aspects of your subject?
- Do your shapes look three-dimensional? How could you have enhanced their three dimensional appearance?
- Are all of your shapes regular or symmetrical?
- What shapes look most effective?

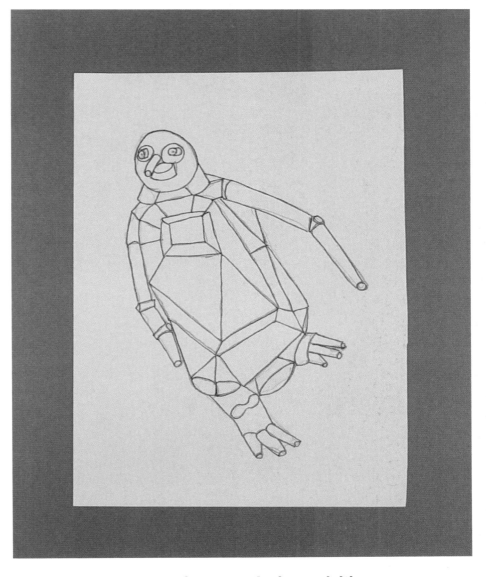

Variations

- Students trace their 3-D shapes using coloured pens.
- Students draw an imaginary robotic creature using a combination of 3-D shapes.
- Draw a three-dimensional shape and 'build' onto it to create a three-dimensional creature.
- Draw a simple three-dimensional shape and use shading to enhance its dimensions.

Cross-curricular activities

- Use paper or cardboard nets to construct 3-D models using a combination of many simple 3-D shapes.
- Introduce new 3-D shapes and their properties; for example, dodecahedrons and other more complex polygons.
- Calculate the volumes of three-dimensional objects.
- Construct transparent cubes using straws for edges and cellophane for faces.

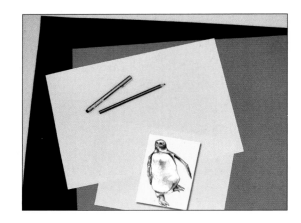

✏️ **Resources**
- picture to copy
- white paper (A5)
- lead pencil
- black fine-tipped pen
- card for mounting

Indications:

Skills, techniques, technologies and processes

- Draws a set image within the confines of a circle to create a circular design.
- Mentally visualises an image stretched and squashed to assist in drawing.

Responding, reflecting on and evaluating visual arts

- Understands the difference between a design in a circle and a circular design.

Inspiration

- Discuss how an object could be squashed or stretched to fit inside a shape. For example, attempt to draw a square flower (not a flower in a square).
- Look at examples of circular designs on stickers, plates and packaging. Discuss whether they are circular designs or designs inside circles.

Instructions

Step 1

Find a picture of a subject that has distinct dark and light areas. The picture could be from a magazine, a photocopy of a picture from a book or printed from the Internet.

Draw a circle on a sheet of A5-sized paper by either drawing around a circular object or using a compass.

Step 2

Look at the subject and think about how it could 'morph' into a circular shape. Which parts would stretch? Which would shrink? Imagine how the subject would look in a circular shape. It is important the students understand that they are not simply drawing their subject in a circle, but the subject itself is to alter to become circular. It may help to have the students imagine their subject blown up like a balloon.

Use a pencil to draw the subject so that it extends to the boundaries of the drawn circle as much as possible.

Step 3

Use a fine-tipped black pen to trace over the circular design and create a more defined drawing. Some dark areas can be coloured completely in black.

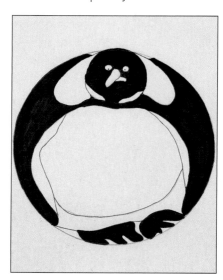

Circular design

Step 4

Mount on a conservative colour (burnt orange, navy blue, olive green, maroon) and then onto black. Encourage the students to complete other developmental drawing activities and to produce a personal portfolio of 'technique' drawings using the same subject. The completed drawings could be displayed as a series using a long single mount.

Reflection questions

- Does your subject stretch to all boundaries of the shape? Can you still make out your original subject or is it too distorted?

- Is yours a circular design or a design in a circle? Can you explain the difference?

- Which areas did you choose to colour black? Why did you choose those areas?

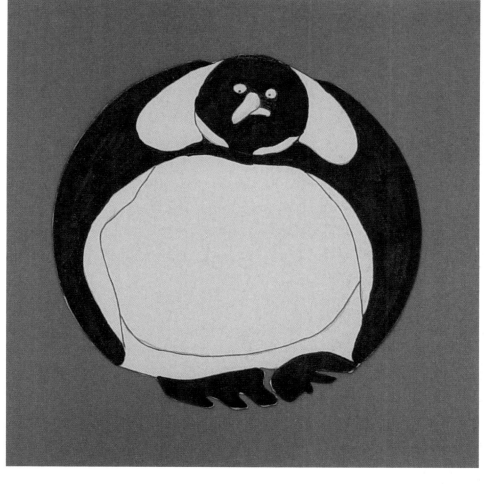

Variations

- Students trace and colour their shape designs using coloured pens.
- Students draw a grid of squares or triangles with everyday items stretched and squashed to fit within them.
- Transfer a circular (or other shape) design onto a T-shirt. Use a screen or lino block to print it.
- Create circular designs and make them into badges to wear.

Cross-curricular activities

- Students design and make an invention based on circles to solve a problem; for example, an invention to collect student papers after an exam in the classroom.

- Provide the students with newspaper, string and sticky tape and have them design clothing and dress a peer as a model for their design. Discuss the difficulties associated with creating objects to fit a given shape.

- Investigate materials that stretch or are malleable. Brainstorm and list uses for these materials.

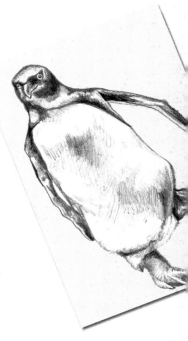

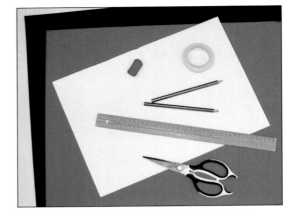

Resources

- round object to trace or a compass
- ruler
- lead pencils
- eraser
- white paper
- red and black card for mounting
- scissors

Indications:

Skills, techniques, technologies and processes

- Uses increasing pressure on a pencil to create a darkening tonal gradation.
- Contrasts gradations against each other to create three-dimensional effects.

Responding, reflecting on and evaluating visual arts

- Appreciates the way gradual shading can be used to create an illusion of depth and perspective on a flat surface.
- Enjoys experimenting with tonal gradations to create an optical illusion.

Inspiration

- Provide the students with clay, plasticine or playdough to roll into several balls. Shine a torch on the balls to cast shadows. Students sculpt each ball on one side to create shaded areas.
- Use lead pencil to colour shade strips from light to dark.

Instructions

Step 1

Measure and divide a piece of art paper into six equal sections. Rule lines to define them. Inside each section, use a compass to draw a circle or trace a circular shape. Each of the circles should be the same size.

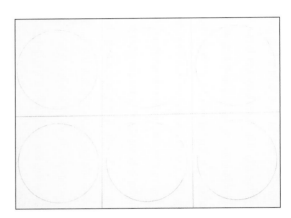

Step 2

Inside each circle, use a ruler to mark sections or draw smaller circles using a compass. In this activity, the objective is to create dark and light tones using lead pencil. This will create depth or perspective within each of the flat circles. Each circle should have a simple design that can be shaded to give a particular effect. Consider the effect you are trying to achieve as you draw in the lines that will form the basis for your shading. One or two of the circles can be left blank to allow you to experiment with creating a spherical shape or a deep hole.

Step 3

Use a 2B or 4B pencil to shade the segments of the circles from very dark to very light to create depth or a three-dimensional effect. Consider where the light source is for each circle and attempt to draw shading to indicate its presence. Stand back from the drawings to assess whether the desired effect has been achieved. If not, rework each circle until the desired image has been achieved.

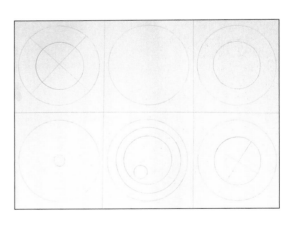

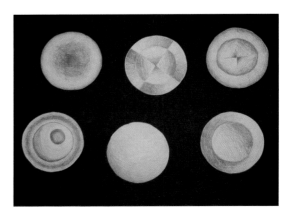

Shadow spheres

Step 4

The circles can be displayed in a number of ways. They could be mounted in a long single row displayed vertically or horizontally, laid out in a pattern and mounted in a particular shape, or mounted onto a large circle shaded as a sphere on a black background. The students should be encouraged to think laterally and find a unique way of presenting their work.

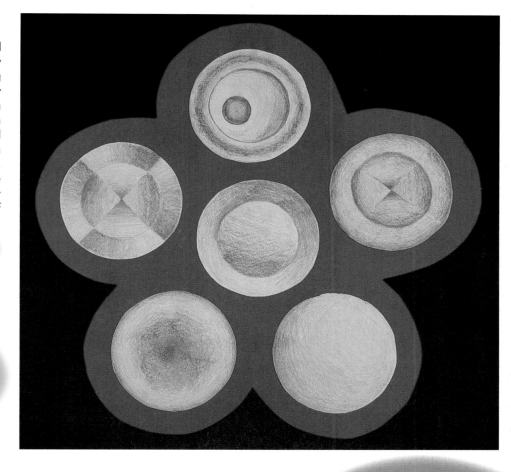

Reflection questions

- How did the way you shaded alter the flat circle you began with?
- How else could you have mounted your circles? Would this look more or less effective than the way you chose to mount them this time?
- What other situations might this kind of shading be used in?

Variations

- Attempt to shade other flat shapes to give them a three-dimensional quality.
- Use shading to create optical illusions. For example, challenge the students to shade a piece of paper to look as if it is curling up, crinkled or corrugated.
- Apply shading to cartoon style drawings of people, animals and buildings to give a three-dimensional effect.

Cross-curricular activities

- Play circular ball games.
- Compare the properties of a series of balls, including clay balls, polystyrene balls, wooden balls, and inflatable balls. Compare their mass and volume.
- Find the volumes and surface areas of different three-dimensional shapes.
- Design a game that uses a ball. Trial the game and evaluate it according to fairness to players and enjoyment.

Indications:

Skills, techniques, technologies and processes

- Uses focal points to create accurate perspective.
- Uses the 'eye' to check for discrepancies in proportion and perspective.
- Joins lines correctly to create the illusion of perspective.

Responding, reflecting on and evaluating visual arts

- Appreciates that lines can be used to transform flat shapes into three-dimensional images.
- Understands the role of shadows in transforming flat shapes into shapes with depth.

Inspiration

- If possible, take the students to a place where they can see the horizon. Note the close and distant elements and their relative sizes.
- Look at a picture of a horizon and draw focal points at either end. These describe the field of vision.
- Look at pictures of tall buildings. Discuss what can and cannot be seen and how distance has been described through lines.

Resources

- coloured felt-tipped pens
- coloured pencils
- black fine-tipped pen
- 2B and HB lead pencils
- ruler
- eraser
- red or black card for mounting
- white paper
- green and blue paper squares
- scissors

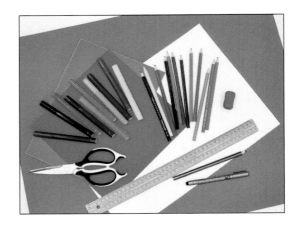

Instructions

Step 1

Using a ruler and an HB pencil, draw a 'horizon' across the page two-thirds of the way down. At either end of the line, draw dots that will become 'vanishing' points. Draw a vertical line somewhere along the length of the horizon. This line will become the corner in the picture and need not be directly in the middle.

Step 2

Using a ruler and an HB pencil, draw a series of lines from the vanishing points at either end of the horizon to the corner line. These will create the buildings. Draw a series of vertical lines across the page to become separations between the buildings.

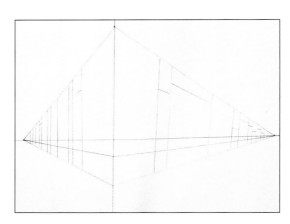

Step 3

Use a 2B pencil to redraw and define the buildings you created. Draw additional lines to create the depth of the buildings by lining up the point between the top corner of the building and the vanishing point at the opposite edge of the paper and drawing in the missing building part. Add detail such as shop signs, windows, doors and a road with traffic lights at the corner. Use a soft eraser to remove any unwanted guide lines.

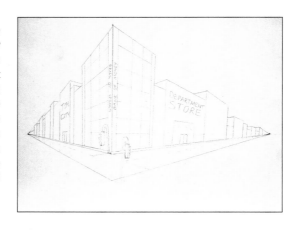

Perspective city

Step 4

Use a fine-tipped black pen to outline the city corner and coloured pencils and felt-tipped pens to enhance the details. Cut out the cityscape and glue onto green and blue paper squares using the angles of the paper edges to match the perspective angles in the drawing. Mount on red or black card.

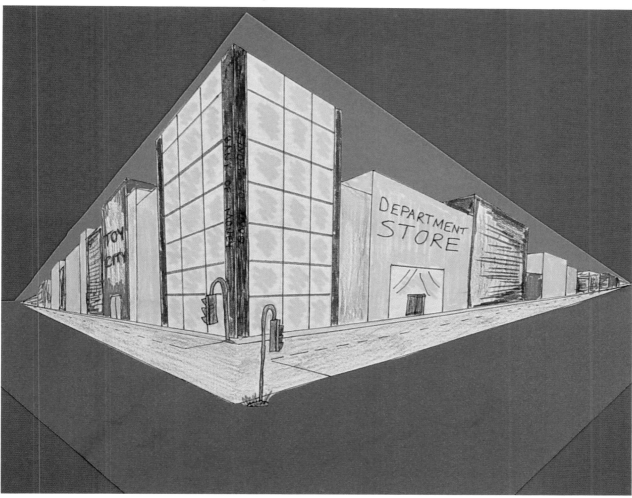

Reflection questions

- Do you think your drawing looks effective? In what way?
- Was it confusing? Did you make any errors?
- What aspect did you find most difficult?
- What did you add to your picture to make it more lifelike? Are you happy with these additions and the finished drawing?

Variations

- Draw 3-D lettering to write names on book covers or as a special title on project work.
- Add shadows to a perspective drawing to indicate what time of day it might be.
- Transform 2-D shapes (with both straight and curved edges) into prisms.
- Draw a perspective drawing of a futuristic space city.

Cross-curricular activities

- Measure long distances such as the perimeter of a school building using a trundle wheel.
- Construct 3-D shapes from 2-D nets drawn onto grid paper or using construction sets.
- Measure and compare the volumes of a range of boxes.
- Draw 3-D shapes onto grid paper and find their volumes according to a given scale.

Resources

- mauve, yellow and aqua paper squares
- greasy coloured crayons
- scissors
- aluminium foil
- glue
- pink card for mounting
- lead pencil

Indications:

Skills, techniques, technologies and processes

- Constructs lines and textures using different amounts of pressure.
- Chooses colours to represent a range of atmospheres and emotions.

Responding, reflecting on and evaluating visual arts

- Responds to emotions through line, shape, texture and colour.
- Expresses feelings and emotions through artwork.

Inspiration

- Look at advertising brochures. Discuss the colours used and why they were chosen. Consider the atmosphere created or emotional response to these colours.
- Students analyse different types of patterns and attempt to describe what the artist was thinking at the time.

Instructions

Step 1

Choose three differently coloured paper squares. The three colours should include a bright colour, a softer colour and a darker (but not black) colour. Fold each paper square in half four times so that when opened the paper is divided by crease lines into sixteen equal squares. Cut the paper into sixteen squares.

Make piles of four squares of the same colour so that there are eight piles altogether.

Brainstorm a list of emotions or feelings. Choose an appropriate colour for each of the emotions and write that emotion on the back of the four squares in one pile. Repeat for each pile of four squares. For each square, the students will need to express that emotion as either a colour, shape, line or pattern. Write 'colour', 'shape', 'line' or 'pattern' on the back of each of the four squares in each group.

Step 2

Use greasy crayons to express each of the emotions as indicated on the back of each paper square.

Step 3

Develop a system for arranging the paper squares according to a personal criterion; for example, all of the same emotion in a row or all like shapes grouped.

Emotional line and design

Step 4

Transfer the arranged squares onto a strip of aluminium foil and glue them down to secure. Carefully lay the foil over a suitably coloured mount. Alternatively, make aluminium foil shapes to suit the arrangement and mount onto the foil shapes.

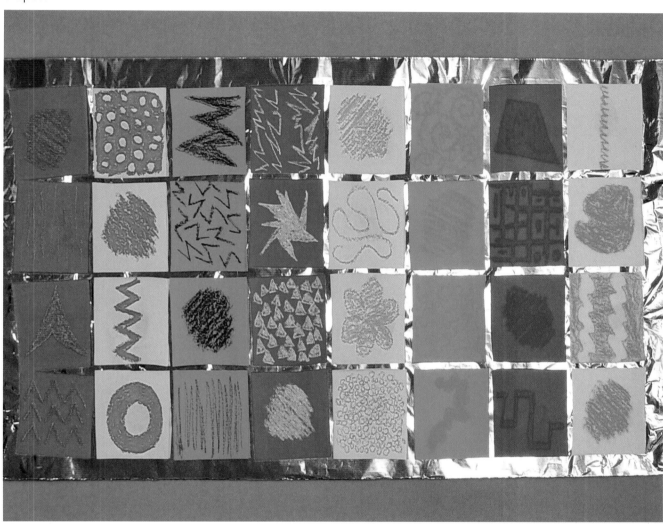

Reflection questions

- How did you use colour to describe different emotions?
- What colours are 'sad', 'quiet', 'loud', 'happy' or 'angry'?
- Was it easy to create so many different patterns? Were any similar?
- Did you draw any of the same shapes as other people in the class without seeing what they had done beforehand?

Variations

- Make 'surprise' boxes illustrated in 'surprise' colours and patterns.
- Draw or decorate greeting cards for different occasions. For example, a sympathy card would be illustrated with a different 'tone' from a birthday card.
- Draw lines and patterns in response to contrasting pieces of music.

Cross-curricular activities

- Look at the media and how emotional colours and designs are used to persuade the consumer.
- Design packaging for a children's toy.
- Read classified ads and brochures. Note the persuasive words used. Attempt to write a classified advertisement.
- Make and illustrate a holiday brochure.

Resources

- pink pastel paper
- pastels
- card for mounting
- hand towels

Indications:

Skills, techniques, technologies and processes

- Holds pastels in a way that is comfortable and enables controlled drawing without smudging.
- Experiments with techniques such as smudging to enhance a pastel drawing.

Responding, reflecting on and evaluating visual arts

- Respects the powdery nature of pastels and the way colours can be carefully mixed on the page.
- Enjoys working on textured or coloured paper.

Inspiration

- Look at pastel drawings such as *Maternity* by Picasso (1903). Note the paper used.
- Allow the students to handle pastels and experiment with their unique qualities.
- Experiment with pastels on differently textured papers and cards.
- Discuss the types of drawings pastels would complement.

Instructions

Step 1

Due to the unique texture and properties of pastels, it is advised that the students have ample opportunity to experiment with them prior to drawing their final artwork on special paper. The students should also be provided with hand towels for wiping 'smudged' fingers during the process and avoid marking their artwork unintentionally.

Draw a simple outline of an imagined parrot in flight. Consider the colours you will use. What will look good against the coloured paper you chose?

Step 2

Use fingers to smudge and spread the 'feathers' of the bird, working from the lightest colour to the darkest colour. Mix the colours in places to blend the body or feathers together. Where definition is lost with smudging, use the pastels to redraw the affected areas.

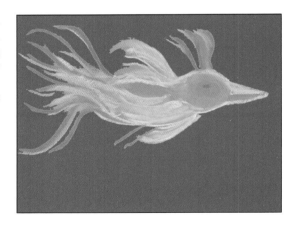

Step 3

Create a 'sky' by drawing lines that indicate air flow around the bird in flight. Select only one or two colours that will blend well with the paper colour you chose. The sky should not be as vibrant in colour as the bird, but should be subtle enough to focus attention on the subject.

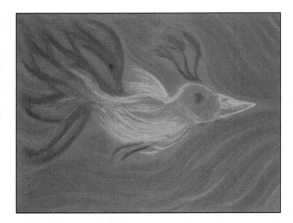

Pastel parrot

Step 4

Make any finishing touches or complete the detail on the bird, but do not overwork the drawing. With pastels, too much redrawing and reworking will detract from the artwork. Mount simply on a bright background that complements the paper colour chosen.

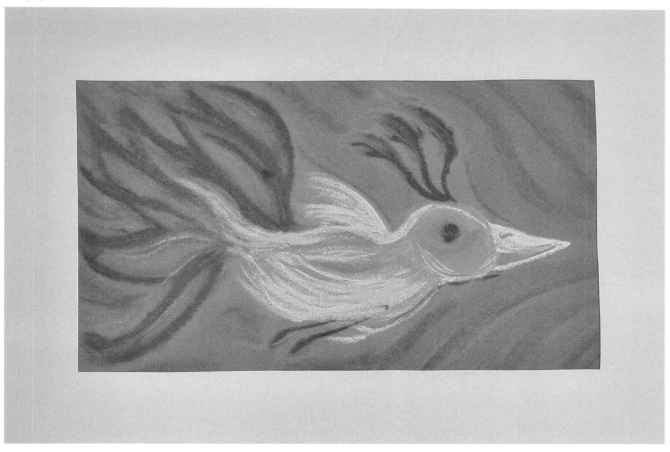

Reflection questions

- How were pastels different from pencils to draw with?
- Did you encounter any difficulties using pastels?
- What could you do with pastels that you couldn't do with pencils?
- Were you pleased with the bird you created? Would you do things differently next time? In what way?

Variations

- Use pastels to colour simple shapes. Encourage the students to mix the pastels on the paper and to attempt shading to give a three-dimensional effect.
- Use pastels on different coloured papers and textured surfaces.
- Use pastels to create a sunset sky with a solid yellow sun.

Cross-curricular activities

- Identify birds found in the local natural environment.
- Investigate the history of flight. Students design and make their own model aircraft. Trial them in an open field.
- Write and illustrate a junior fiction book about an exotic bird to share with younger students. Encourage the students to illustrate their stories using pastels.

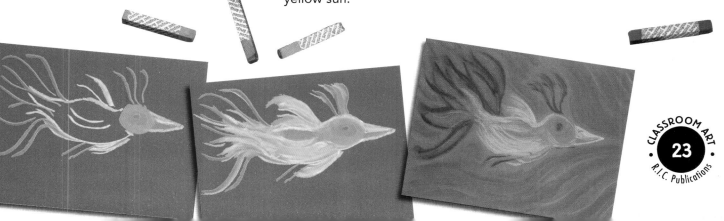

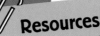

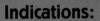

Resources

- purple card for mounting
- coloured felt-tipped pens
- lead pencil
- white paper
- coloured pencils

Indications:

Skills, techniques, technologies and processes

- Draws flat exaggerated shapes to represent the features of a person.
- Identifies and draws elements of a person's life and behaviour to represent him/her.

Responding, reflecting on and evaluating visual arts

- Recognises the cartoon style as unique from other drawing styles.
- Identifies a caricature as a means of accentuating elements of a person's personality through exaggerated drawing.

Inspiration

- Students bring in cartoons from home to share with their peers. Discuss the types of stories or situations that are used in cartoons.
- Look at caricatures of famous people. Note how certain features are accented while others are minimised.

Instructions

Step 1

Choose a subject for your caricature. The simplest subject to use (and most enjoyable for the students) is the teacher. Discuss the prominent facial features of the subject. In caricatures, some features are exaggerated, while others are reduced. The aim is not to draw a realistic portrait, but rather to capture the main features of a person and emphasize them. Decide what are the main facial features of your subject and draw them accordingly. Consider that the shape of the head itself may be a notable feature and could be made prominent.

Step 2

Look at the subject's clothing and environment. They may tell you something significant about the person's lifestyle. Draw your subject's body disproportionately small in comparison to the head and clothe it in a way that says something about the personality or lifestyle of the subject. Similarly, draw in a simple background of objects or accessories the subject might be holding to describe notable aspects of his/her life.

Step 3

Think of something typical the subject might say. If the subject is well known to you, this will be easy and a lot of fun. Draw a speech bubble with a typical phrase written inside it.

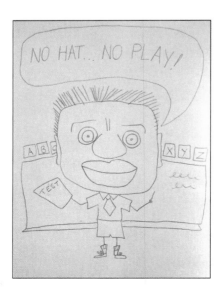

Caricature

Step 4

Outline the drawing in coloured felt-tipped pens and colour using coloured pencils. Mount on card in a fun colour. Display in an area where people from other classes can view them and attempt to guess the subjects.

Reflection questions

- What features did you attempt to exaggerate on your subject? Why did you choose these features?
- Is your caricature recognisable as your subject?
- How do you think cartooning is unique from other types of drawing?
- Could you see yourself becoming a cartoonist in the future?

Variations

- Draw a cartoon strip using original cartoon characters.
- Draw a 'self-caricature' to accompany a personal profile or mini-autobiography.
- Create a moving cartoon using the corner of a booklet to make a flip book.
- Use a cartoon to make a political statement about a current affair.

Cross-curricular activities

- Make a 'storyboard' of simple cartoons as the foundation for story writing or as a prompt for a puppet play.
- Investigate the way cartoons are used in the media to advertise or present information or to make a social comment.
- Find out about the lives and work of famous cartoonists such as Charles M Schulz or Walt Disney.

Glossary – Drawing

array	well-ordered series of things
caricature	grotesque representation of person or thing by exaggeration of characteristic traits
density	closeness of elements
design	the art of arranging lines, drawing, decorating or distinguishing a thing
developmental drawings	a series of drawings using a variety of different techniques to explore a single subject
exaggerated	enlarged beyond the limits of truth
focal point	main point of interest or attraction
hatch	to draw a series of lines which vary in proximity to create the effects of light and dark
mount	to fix on or in a position or setting
palette	a thin board used by painters to mix colours on
pastel	(a) a soft pale colour (b) a soft, chalky crayon (c) a drawing made with soft chalky crayons
perspective	the appearance of distance as well as height and width, produced on a flat surface
pointillism	method of producing light effects by crowding a surface with small spots which are blended by the viewer's eye
portfolio	case for keeping loose sheets of paper, drawings and so on
proportion	dimensions, size
proximity	nearness
subject	something chosen by an artist for painting

Useful websites

Artists and art movements

National Gallery of Art	www.nga.gov
Time line of art history	www.metmuseum.org/toah/splash.htm
Terminology and art index	www.artlex.com
Pablo Picasso	www.picasso.com/

Tools and techniques

Caricature zone	www.magixl.com/
Drawing in one-point perspective	www.olejarz.com/arted/perspective/
Relief shading	www.reliefshading.com

Art education

The incredible art department	www.princetonol.com/groups/iad/
Magical places and creative spaces	www.committed.to/curriculum

PAINTING

Resources

- all paint colours
- scissors
- pencil
- red coloured paper square
- yellow card for mounting
- fine paintbrush
- white paper
- mixing palette
- glue
- newspaper

Indications:

Skills, techniques, technologies and processes

- Draws an imaginary beetle that 'fills the page'.
- Mixes two colours at a time to create new colours for a painting.
- Uses fine-tipped paintbrushes to apply paint to intricate shapes.

Responding, reflecting on and evaluating visual arts

- Identifies 'exotic' colours and combinations of colours to paint a beetle picture.

Inspiration

- Look at pictures or discuss beetles with unusual features. Note their body shape and colour.
- Allow students to make a series of simple developmental sketches incorporating some of these unusual features. Encourage students to develop their own unusual features.
- Give the students opportunity to experiment with colour mixing.

Instructions

Step 1

Use a lead pencil to draw an 'exotic' beetle. 'Exotic' in this context simply means 'from somewhere else'. Therefore the design can be as imaginative as possible and should include plenty of detail so that it can be coloured with many different colours.

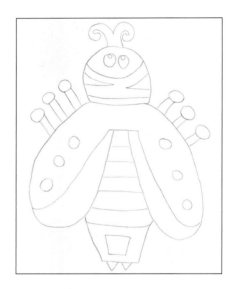

Step 2

Put small amounts of primary and secondary colours, and white, onto a palette that is big enough to use for mixing new colours. Select and paint shapes in the drawing in unmixed primary and secondary colours. Mix only two colours at a time to create new colours for the remaining shapes. Not all colours mixed need be used. Use only those that will look good on your beetle. Think about what colours will look good side by side as you go. For example, choose complementary colours to make some shapes stand out (for example, yellow spots on purple wings) and analogous colours for others (for example, greens, yellows and oranges on the body).

Step 3

Cut around the beetle, leaving a 5 mm margin around the entire shape. Cut two narrow strips of coloured paper and set them aside.

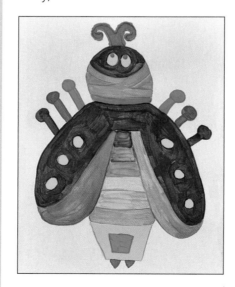

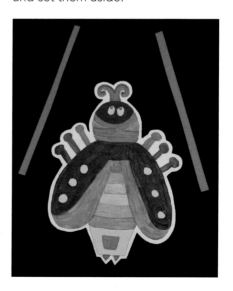

Exotic beetle

Step 4

Glue the exotic beetle onto a bright background. Cut the coloured paper strips into segments of equal length and glue them onto the background, trailing the beetle in a loopy pattern.

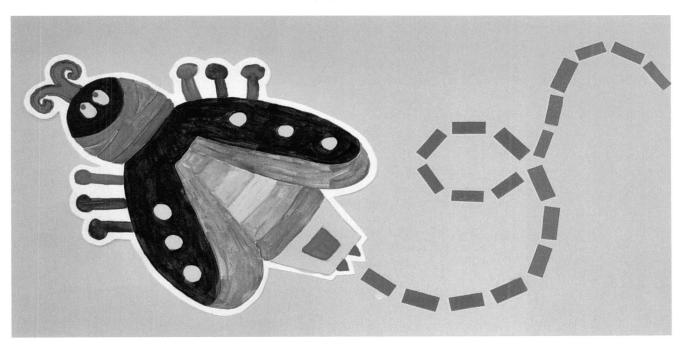

Reflection questions

- Is your beetle unique?
- What unusual colours did you mix? Can you give them an unusual name to match?
- Did all the colours you mixed go well together? Why?
- How could your beetle have been made even more exotic?

Cross-curricular activities

- Go on a beetle hunt in the local natural environment. Catch and observe the beetles and then release them.
- Investigate the needs of living things and in particular the needs of insects.
- Find out about skeletons and exoskeletons and the reasons why some creatures might need a skeleton on the outside of their body.

Variations

- Paint other 'exotic' creatures such as birds, fish or butterflies.
- Paint pictures that include tonal gradations where the students are encouraged to mix two colours in varying quantities, moving from one to another; for example, from blue to yellow in the leaves of a tree.

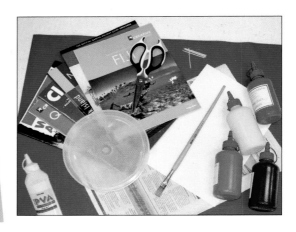

Resources
- white paper
- yellow, green, blue and purple paint
- paintbrush
- toothpick
- magazines/brochures/catalogues
- newspaper
- dark green card for mounting
- scissors
- glue

Indications:

Skills, techniques, technologies and processes

- Selects magazine pictures that fit with a chosen analogous colour scheme.
- Blends paints on the paper to create an analogous painting.
- Uses the end of a paintbrush to etch patterns or pictures into a wet surface.

Responding, reflecting on and evaluating visual arts

- Identifies analogous colours on a colour wheel.
- Matches magazine pictures to sections of a painted background where they will 'blend' most effectively.

Inspiration

- Listen to 'rainforest' relaxation style music. Imagine the creatures that might be found there.
- Browse through travel brochures, catalogues and magazines to find pictures of rainforest animals, birds, insects or plants.
- Review colours that might be found in a rainforest. Include a dark blue or purple to represent depth and shade.

Instructions

Step 1

Look at the colour wheel and identify analogous colours. Select three analogous colours to be the base for your artwork. Browse through magazines and cut out several pictures that are predominantly in these colours. From these pictures, select three or four that could be incorporated into one theme for your artwork.

Step 2

Prepare an area to work on. Cover it with newspaper. Squirt stripes of your analogous colours onto a sheet of white art paper. Use a paintbrush to spread the paint, mixing them slightly on the paper so that they all blend together gradually, creating some new colours, but not losing the original colours entirely. Use the opposite end of the paintbrush to 'etch' patterns or pictures into the wet paint, describing the environment for the theme you have chosen; for example, a squiggly forest or ripply water. Allow the painting to dry.

Step 3

Place the magazine pictures onto the painting and move them around the page until their colours best blend with the background and fit the scene to make a sensible picture. Glue the pictures into position.

Analogous colours

Step 4

Mount the finished painting onto a background of one of the analogous colours chosen. Where a group of students have selected the same theme, the work can be all mounted onto one background colour to create a 'rainforest' or 'underwater' scene.

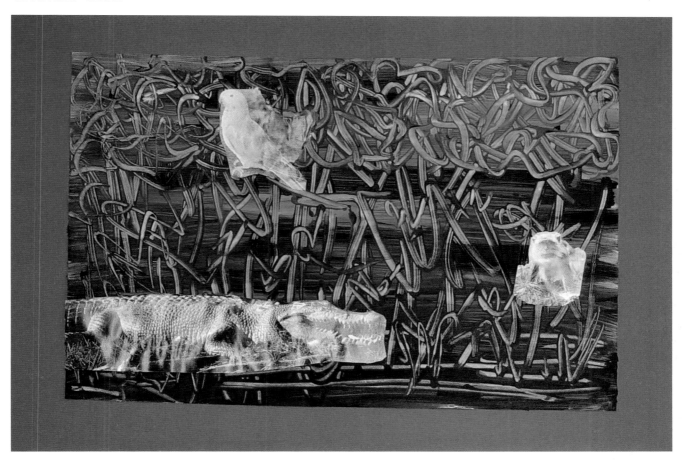

Reflection questions

- Etch camouflage drawings into wet paint applied thickly to the page; for example, a lizard crawling up a sand dune, a sea anemone on a rock pool or a grasshopper on a shrub.
- Use other tools such as a comb or steel wool to etch into wet paint.
- Take prints of etched paintings to remove excess paint or to explore a different effect.

Variations

- Could the picture you found be easily camouflaged against the background you painted? What could you do to help create a better camouflage?
- Describe the lines you scratched into the wet paint. Why did you make those types of lines? What impression do they give?

Cross-curricular activities

- Look at a map of the world and colour the parts where rainforests exist.
- Compare creatures that are bright colours (red, yellow or black) to creatures that are green. Discuss how these differences help each creature.
- Compare dry and wet environments. Brainstorm and list differences in plant life, animals and the ways humans inhabit these environments.

Resources

- brown edicol dye powder
- water
- strong glue
- sand
- bleach
- white paper
- paintbrush
- cotton buds
- newspaper
- orange card for mounting

Indications:

Skills, techniques, technologies and processes

- Applies dye to paper to create a water-wave effect.
- Uses a cotton bud to apply bleach and create or reproduce an image.

Responding, reflecting on and evaluating visual arts

- Assesses whether an image can be improved with additional applications of dye or bleach.
- Acknowledges that colours other than blue can be used to represent ocean scenes effectively.

Inspiration

- Discuss invisible ink pens or pens which change colours.
- Discuss what bleach is and its uses.
- Perform an experiment showing how bleach added to a glass of dyed water makes it clear again.
- Look at pictures of microscopic marine life. Note the transparent nature of these creatures.

Instructions

Step 1

Prepare a solution of brown edicol dye by mixing the powder with water. Cover the area to be used with a thick layer of newspaper or plastic sheeting. Note that edicol dye does not come out of clothing and a protective covering should be worn. Use a thick paintbrush to apply dye to a piece of art paper. Completely cover the paper and place it on a flat surface to dry.

Step 2

Pour a small amount of bleach into a container. Note that bleach will strip colour from clothing, carpets and some work surfaces. Therefore, it is important to ensure all surfaces and clothing are protected. Dip the tip of a cotton bud into the bleach and use it to paint a single line onto the dyed paper. It may help to have drawn a crustacean design on a separate sheet of paper to copy. As the bleach penetrates the dye and paper it will strip the colour, leaving a white or lighter pattern. Where a lighter section is required, two or three coats of bleach may be required.

Step 3

Continue painting the crustacean, using double or triple strength in areas as required to enhance the underwater effect. Place the finished painting on a flat surface to dry.

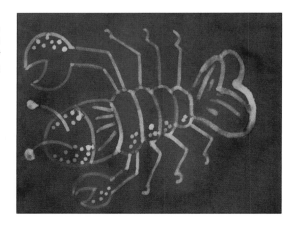

Bleached crustaceans

Step 4

Dribble strong glue around the perimeter of the drawing and, while wet, sprinkle with sand to create a border. Mount onto a background similar in colour to the dyed paper.

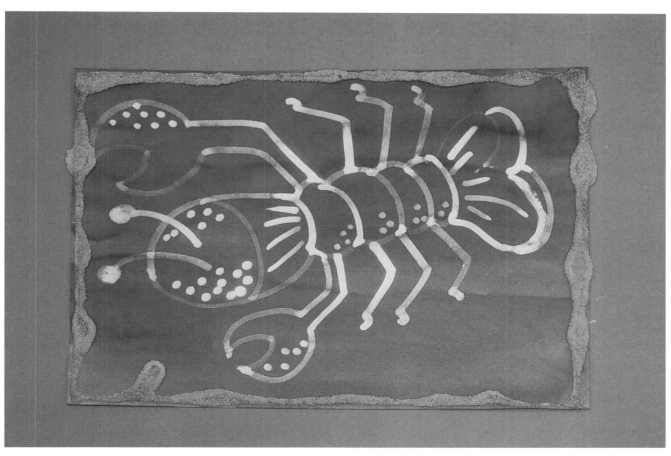

Reflection questions

- Describe what bleach was like as a medium to paint with.
- What difficulties did you encounter painting with bleach?
- Did your painting work out as you expected? How was it different?
- Does the image you created remind you of anything?

Variations

- Use bleach in a mixed media artwork to make borders or 'sharpen' images.
- Paint fine lines and drawings in developing solution onto photo paper and leave in the sun to create an image of microscopic sea creatures with translucent qualities.
- Paint wax designs onto fabric and dye (batik).

Cross-curricular activities

- Use magnifying glasses to discover tiny things.
- Look at slides of leaf tissue or water droplets under a microscope to find microscopic creatures and cells.
- Students invent and perform a 'disappearing' magic act for the class.
- Research or teach simple magic tricks.

Resources

- paper napkins/towel
- scissors
- pink and gold card for mounting
- fine-tipped black pen
- pencil
- fine paintbrush
- wide paintbrush
- white paper
- sponge
- red, orange, purple, white and blue paint
- newspaper
- glue

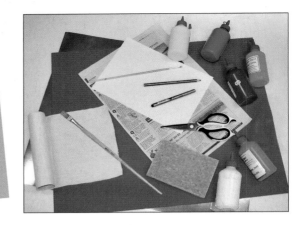

Indications:

Skills, techniques, technologies and processes

- Uses a sponge to remove and apply paint to achieve a particular effect.
- Combines collage materials with painting tasks.

Responding, reflecting on and evaluating visual arts

- Recognises the techniques and images associated with 'surrealism'.
- Describes why their painting is 'surreal' in their own words.

Inspiration

- Look at surrealistic paintings such as *Apparition of a face and a fruit dish on a beach*, by Dali (1938). Discuss the distinctive features of surrealism.
- Discuss the meaning of the statement 'when pigs fly'. Students suggest things they might do 'when pigs fly'.
- Discuss the difference between real and 'surreal'.

Instructions

Step 1

Prepare the work space with newspaper. Use a wide paintbrush to paint a blue and white 'sky' background. The sky can be a solid colour or slightly variegated. While the paint is still wet, dab a dry sponge onto the surface to remove small sections of paint, creating the effect of distant clouds. Dab the sponge into white paint and apply sparingly to the sky to create clouds that appear closer.

Step 2

On a separate sheet of paper, draw outlines of three or four pigs of various sizes in lead pencil. Think about what the pigs might look like if they were flying. What position would their legs be in? How would their ears and tail look?

Fold a paper towel or patterned paper napkin in half. Cutting into the folded edge, make a wing shape. Unfold the wing shape to reveal the second wing. Make a pair of wings for each of the pigs.

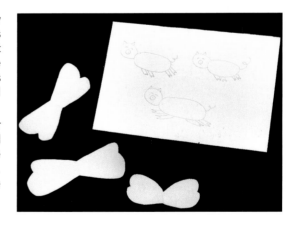

Step 3

Mix the red, orange and purple paints with white to create three pastel colours. Paint each of the pigs in a different pastel colour with a fine paintbrush. When dry, outline the pig shapes, adding detail such as a nose, eyes and a curly tail to each with black pen.

Splay the wings sideways so that both wings can be seen. Refold in the new position. Glue one set of splayed wings onto the back of each pig.

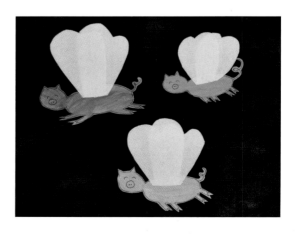

Surreal pigs

Step 4

Glue the pigs onto the sky background as if flying through the air. Mount on gold card against a vibrant pink or purple background.

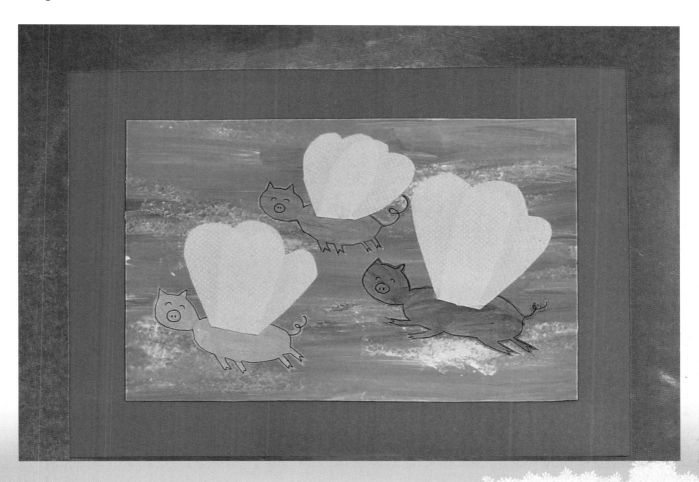

Reflection questions

- Does your picture look 'surreal'?
- How else could you have combined reality and fantasy in a painting?
- What do you think your painting expresses to other people?
- What were you hoping to communicate through your painting?

Variations

- Create pictures where one thing 'morphs' into another; for example, a snake head with a ribbon tail or a limb with a hand at one end and a foot at the other.
- Incorporate a collage of magazine clippings to describe the 'real' aspects of a surreal painting.

Cross-curricular activities

- Students write 'unbelievable' stories about events that would only happen 'when pigs fly'.
- Encourage the students to stretch their imagination and create an original character for a storybook. Use the students' characters to construct a class book or classify the characters according to their behaviours or personality traits.

Indications:

Skills, techniques, technologies and processes

- Realigns shapes to create an 'impression' of a subject.
- Follows a system to decide how to create a new picture from parts of an old one.

Responding, reflecting on and evaluating visual arts

- Recognises the techniques and images associated with 'cubism'.
- Understands that a picture does not need to be identical to its subject to represent it.

Inspiration

- Look at examples of cubism from the early 20th century; for example, works by Picasso such as *Seated woman*. Discuss what might have inspired the artist to paint in this way and what techniques may have been used. Liken the style to the fracturing of light and images that occurs when a mirror is broken. Focus on the light and dark areas within each piece of the picture.
- Practise shading shapes light to dark.
- Look at pictures of the moon, noting the lighter area that surrounds it. Note also the brightness of the stars further from the moon.

Resources

- coloured card
- blue, white, black and yellow paint
- strong glue
- scissors
- paintbrushes, thick and thin
- pencil
- white paper
- dark blue mount
- newspaper
- ruler

Instructions

Step 1

Draw a simple outline of stars and a full moon to depict the night sky.

Without measuring, rule lines at fairly even intervals both across the page and from top to bottom to create a series of approximate squares.

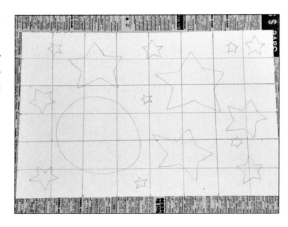

Step 2

Begin painting each square individually. For squares close to the moon, add white to make a lighter blue. For squares further from the moon, add very small amounts of black to make a darker blue. For stars in the darkest part of the sky, use white. As the stars get closer to the moon, add more and more yellow to white. (For an even better effect, paint each square using a gradient from dark to light.)

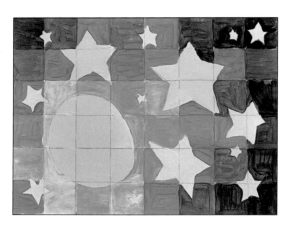

Step 3

When the paint has dried, cut along the ruled lines. Decide what colour and shape you will mount your night sky picture onto and prepare the cardboard. Arrange the squares, starting with the moon pieces at the centre of the cardboard, then placing the remaining squares around them from lightest to darkest. The pieces can overlap if desired, but should not match up against each other exactly.

Cubism

Step 4

When the pieces have been arranged satisfactorily, glue them in place using a paintbrush and strong glue, ensuring all corners are glued securely. Cubism is best viewed from a distance to gain the greatest effect from its fractured nature.

Reflection questions

- Compare your work to the traditional cubist style. How are they alike/different? How do the techniques differ?
- What other technique might also suit a night sky picture?

Variations

- Apply the same technique to a daytime sky using a colour gradient across the spectrum to create a sunset; for example, pink – purple, yellow – orange.
- Experiment with different shapes to suitably frame the image.

Cross-curricular activities

- Define what is meant by 'abstract'. Explore other abstract art forms.
- Investigate how putting 2-D shapes together creates the illusion of three dimensions. Measure and draw cubes from different perspectives, using squared paper.
- Investigate the phases of the moon, what causes its illumination and how eclipses occur.
- Research current space missions and technological advances which increase our knowledge of outer space.

Resources
- red, orange, black and purple paint
- white paper
- scissors
- scrap paper
- various paintbrushes
- card for mounting
- newspaper
- palette

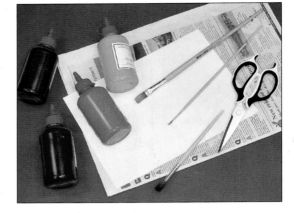

Indications:

Skills, techniques, technologies and processes

- Uses fine brushes to create regular patterns.
- Incorporates colours and patterns that are consistent with a particular style.

Responding, reflecting on and evaluating visual arts

- Attempts to represent a particular culture through artwork.
- Understands that through art, we can learn about a culture or era.

Inspiration

- Provide a Persian-style mat or rug for the students to look at. Note the patterns.
- Allow the students to attempt to copy the patterns on the rug.
- Students start patterns for their peers to copy or complete.
- Discuss the colours that might be appropriate for this style of rug.

Instructions

Step 1

Prepare the work space with a layer of newspaper. Look at examples of brightly coloured rugs. Pour small amounts of purple, red and orange paint onto a palette. In the centre of a sheet of white paper, paint a short wide rectangle as the centre of the rug. Paint lines around the rectangle, alternating the three colours to create bigger and bigger rectangular shapes. When the rectangles reach the top and bottom edges of the page, choose a colour to simply draw stripes down either side to complete the painting. These stripes will later become the fringing of the rug. Allow the painting to dry.

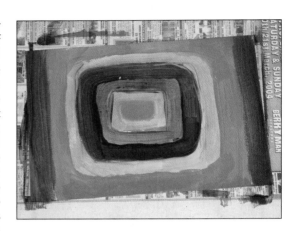

Step 2

On scrap paper, experiment with different finer brushes to create a variety of patterns which could be used on the rug. Paint a pattern onto each of the lines using a containing colour; for example, use orange on purple or red on orange. Introduce black into the 'rug' to create some of the patterns and produce a more striking image.

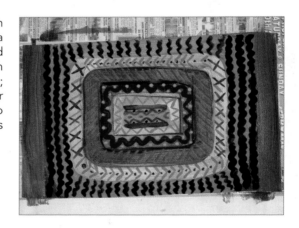

Step 3

Trim the painting to remove unwanted edges and make the rug a more regular shape. Cut fringing at either edge of the 'rug'.

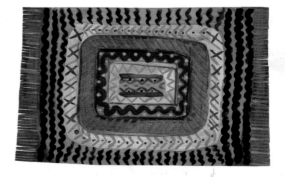

Persian rug

Step 4

Glue onto a 'richly' coloured background. Deep purple or red are suitable choices. If displaying the rugs in a group, add 'riches' such as gold curling ribbon and cutouts of goblets and jugs painted in gold.

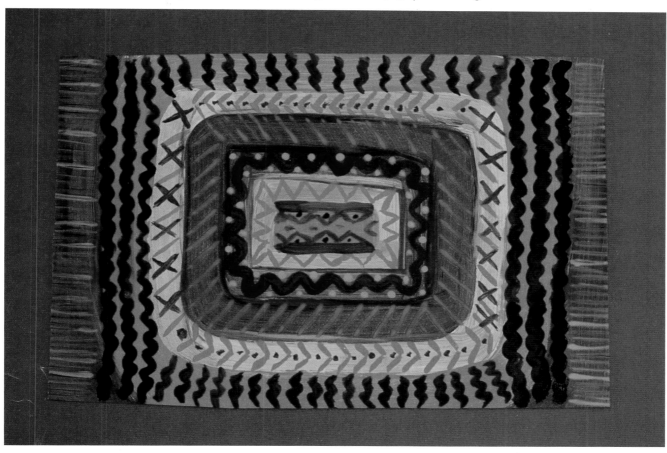

Reflection questions

- Did the chosen colours combine well? Are they appropriate for a rug?
- Would you put a rug like the one you painted in your house? Why?
- What aspects of your painting do you like best?
- What words would you use to describe your rug if you were trying to sell it?

Variations

- Use a variety of drawing materials including crayon, felt-tipped pens and pencils to create a more intricately patterned rug.
- Use coloured paper shapes to create a collage on a large sheet of paper or card in concentric patterns. This activity could be a collaborative effort.
- Glue pieces of wool in concentric circles on a circular piece of card to make a 'coil' rug.

Cross-curricular activities

- Find out what rugs are made from. Investigate natural fibres such as wool, cotton and silk and find out where they come from.
- Keep silkworms in a shoe box for the students to observe over time.
- Investigate natural and synthetic fibres.
- List selected modern inventions and the natural resources they consume.

Indications:

Skills, techniques, technologies and processes

- Mixes black with another colour to create shades of that colour.
- Mixes white with another colour to create tints of that colour.

Responding, reflecting on and evaluating visual arts

- Understands that by using tints and shades, different amounts of light or different times of day can be described.

Inspiration

- Look at 'still life' paintings such as *The breakfast room* by Bonnard (1930).
- Allow the students to experiment with adding black to colours to create shades and adding white to create tints.
- Take photos of an object or 'still life' display in different lights. Observe how the colours change.

Instructions

Step 1

Make an arrangement of fruit to be used as a still life. Place the fruit carefully to create a pleasing display. Use flowers to 'fill' gaps in the display if necessary.

Draw the display, with outlines only, using a lead pencil onto an A5 sheet of art paper. Trace the image onto a second sheet of A5 paper to create two identical drawings. Drawings can be traced easily when the paper is placed over the original and the two put against a window so that light can shine through to highlight the lines.

Step 2

Put small amounts of each of the colours onto a palette. Include a reasonable amount of white paint on your palette. Choose a colour to mix with the white paint. Add more white paint if required to create the tint desired. Repeat using the other colours. Begin painting a 'daytime' image on one of the drawings.

Step 3

Put small amounts of each of the colours onto a clean palette. Include a small amount of black paint on your palette. Choose a colour to mix with the black paint. In comparison to mixing with white paint, only tiny amounts of black paint are needed to make a colour a significantly darker shade. Add more black paint sparingly, if required, to create the shade desired. Repeat using the other colours. Begin painting a 'night-time' image on the other drawing. When the fruits are completed, paint the background black or dark grey.

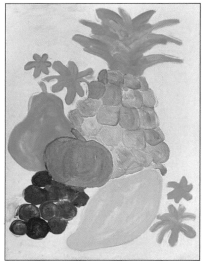

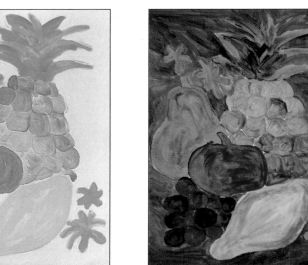

Tints and shades

Step 4

Display the paintings side by side to illustrate how light affects a subject and how this can be described using tints and shades. Write plaques saying 'day' and 'night' to fasten under each of the paintings, once they are mounted on a black background.

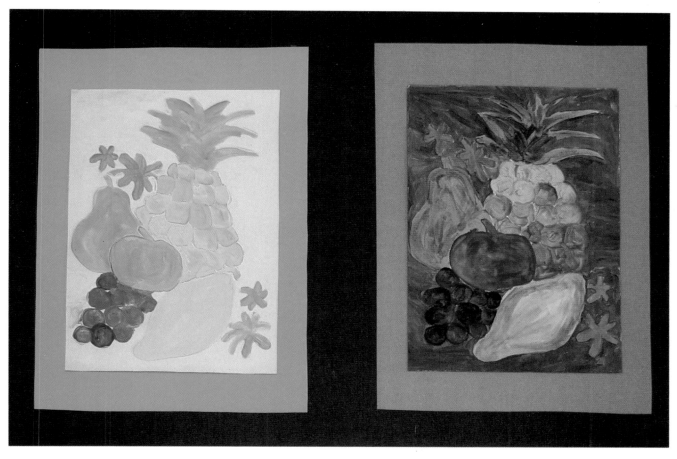

Reflection questions

- What time of day do you think each of your pictures represents?
- How did adding small amounts of black or white to a colour compare with adding large amounts?
- Does your painting resemble the 'still life' you copied?
- Is painting a picture identical to your subject important to your artwork?

Variations

- Try still life drawing using lead pencil only, attempting to create shadow by shading or cross-hatching.
- Attempt drawing or painting a portrait of yourself or a peer 'model' from life.
- Attempt to add shadows to a still life drawing. Provide a light source to show a shadow if necessary.

Cross-curricular activities

- Conduct a series of studies of children's books, making special note of the illustration styles used by each illustrator.
- Discuss the atmosphere or tone set by using tints or shades.
- Write 'dark' spooky stories or 'bright' uplifting stories.
- Discuss different feelings and emotions and the ways we can treat others to induce these feelings in them.

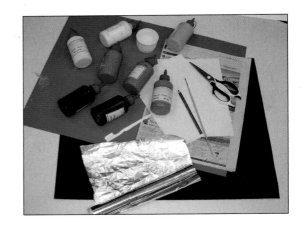

Resources
- white paper
- blue card for mounting
- newspaper
- fine paintbrush
- toothbrush
- water
- all paint colours
- aluminium foil
- scissors
- glue

Indications:

Skills, techniques, technologies and processes

- Uses diluted paint to create a background representative of a coral reef.
- Creates sea creatures by painting and etching an unfamiliar foil surface.

Responding, reflecting on and evaluating visual arts

- Adds appropriate detail and colour to create the impression of a coral reef.
- Places 'close-up' shapes thoughtfully on a coral reef background.

Inspiration

- Look at pictures that show distance and compare them to close-up pictures.
- Make miniature frames and have the students 'frame' things in the environment with the frame held close to and far away from the eye.
- Students look at a land or seascape and imagine the things they might be able to 'zoom in' on.

Instructions

Step 1

Prepare an area of newspaper on which to work. Dilute a small amount of blue paint with equal parts water to paint. Dip a toothbrush into the thinned paint solution and flick the bristles so that the paint 'sprays' onto the art paper. Spray the entire sheet with the blue solution. Some larger drops may result from the process, which will add to the underwater effect intended.

Using undiluted paint in vibrant colours (red, orange, yellow and purple), spray a bottom corner of the page. This will create the impression of a colourful underwater reef viewed from a distance.

Step 2

Using a very fine, round paintbrush, add details such as tiny fish, starfish and coral to the reef. They should appear as though viewed from a distance. Use both undiluted and diluted paint in vibrant colours. Allow to dry.

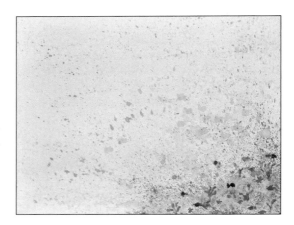

Step 3

Paint large 'close-up' pictures of fish or sea creatures onto a sheet of aluminium foil using colours from the reef. While the creatures are still wet, use the end of the paintbrush to etch in details such as scales or fin 'bones'. Where the paint has been etched, silver foil will show through, giving the sea creature an iridescent effect. Care must be taken to ensure the foil does not tear when painting. Allow to dry.

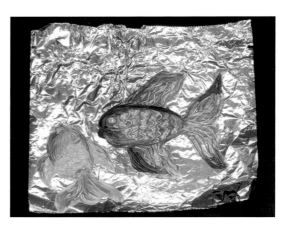

Magnified

Step 4

Carefully cut around the sea creatures painted onto foil. Foil will tear easily so time and care will be needed to carry out this task successfully. Glue the foil shapes onto the splattered reef background. Their size will create the illusion that they are closer to the viewer than the reef background. Display against a blue background.

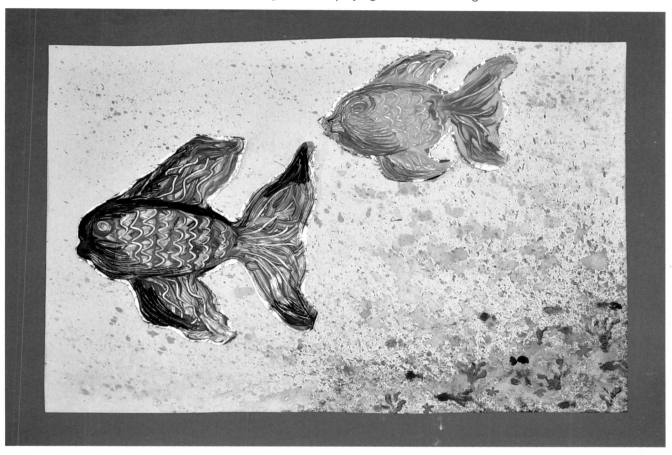

Reflection questions

- Were the subjects you chose from your seascape appropriate?
- Could you have 'zoomed in' further than you did?
- How could you have made your artwork more interesting to the viewer?
- What other subjects would be interesting to view and paint 'close-up'?

Variations

- Draw the same subject from a variety of different angles.
- Draw a landscape from the air to show what could be seen from the window of a plane.
- Draw a bug or beetle in a circle and mount them in the shape of a magnifying glass.
- Mark a small section of a magazine picture and paint it enlarged to give a close-up view.

Cross-curricular activities

- Write descriptions of a miniature landscape from the perspective of an ant.
- Measure small things in millimetres and centimetres.
- Investigate other small measurements such as mL and mg.
- Carry out a case study of a single small plant. Note what lives on the plant and the health of the plant. Investigate the environmental and human impacts on the plant and how they might affect its health and its inhabitants.

Resources

- large sheet of card/paper
- balloon
- fluorescent paints
- string
- fluorescent card for mounting
- newspaper
- scissors
- tripod (See Step 1)

Indications:

Skills, techniques, technologies and processes

- Explores patterns that can be created using a swinging technique.
- Experiments with different starting points and projections for swinging a paint dispenser to create different patterns.

Responding, reflecting on and evaluating visual arts

- Establishes what type of swinging produces the best patterns or effects.
- Recognises that the process of making some patterns contributes to what is perceived as 'art'.

Inspiration

- Prepare a tripod with a container of dry sand hanging from its apex. Puncture the container so that the sand can flow steadily through the hole. Swing the container so that the running sand forms patterns on the ground.
- Propel the container in different ways to create a variety of effects.

Instructions

Step 1

Swing painting can be very messy and needs to be performed in a controlled environment. The students will need to wear protective clothing and use a large 'carpet' of newspaper to cover the floor or an outdoor area. This will allow for unexpected drips or splatters.

Fill a balloon with fluorescent paint and fasten the neck firmly with a length of string. Construct a tripod over the newspaper using three long sticks (board rulers work well) with strong elastic bands at the top to secure them.

Step 2

Attach the end of the string to the apex of the tripod, so that the balloon hangs down in the centre. Place a large sheet of paper or cardboard underneath the tripod to be 'painted'. Pull the balloon to one side, tip upside down and cut a hole the size of a small fingernail in the bottom of it. Squeeze the hole together firmly and allow the balloon to hang downwards again. From the edge of the 'canvas', let the balloon go and watch it create a 'swinging' pattern of paint on the paper or card. The pattern created will vary depending on the projection and force with which the balloon is propelled. To increase the flow of the paint, salt can be added to it before filling the balloon. To decrease the rate of flow, add cornflour to the paint to thicken its consistency. Some paint colours will flow more readily than others.

Step 3

Repeat the process, varying the projection and force used each time, using two or three other fluorescent colours. The colours will work together to produce a unique combination of patterns.

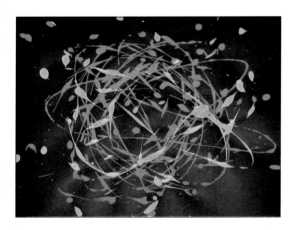

Swing painting

Step 4

Set the artwork aside on a flat surface to dry completely. This may take some time. Glue a complementary fluorescent card frame just inside the border of the painting. This will create a double frame for the artwork.

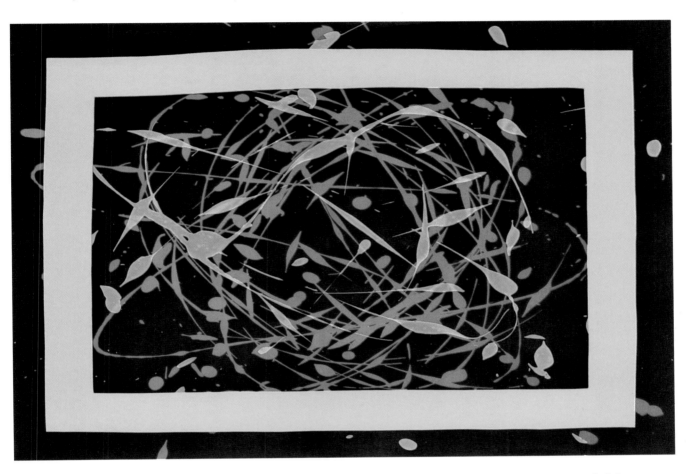

Reflection questions

- Do you think the balloon was an effective container for the paint? What else could you have used?
- Describe the pattern you created.
- Did your pattern work as planned?
- What could you have done to get a better or different result?

Variations

- Spread liquid starch onto a large sheet of paper. Use coloured sands to create swing patterns in place of paint.
- Use a compass to draw circles from a central point and create a symmetrical design.
- Hammer a series of tiny nails into a circle and wind coloured string among them, following a set pattern to create a geometric effect.

Cross-curricular activities

- Investigate the energy sources used to propel objects.
- Find out about things that use momentum to function continually. Look at examples of continual momentum and explore where the energy comes from for them to operate.
- Investigate environmentally friendly and sustainable energy sources and examine how well they are currently being used.
- Examine track and field events where momentum is used to help propel athletes.

Resources

- felt-tipped pens
- water
- paintbrush
- white paper
- card for mounting
- yellow and orange paint
- newspaper

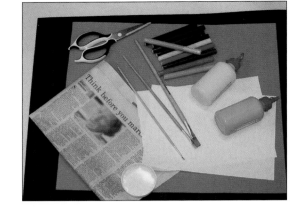

Indications:

Skills, techniques, technologies and processes

- Adds water to a felt-tipped pen drawing to mute colours.
- Draws onto a wet surface with felt-tipped pens to create a 'soft' image.

Responding, reflecting on and evaluating visual arts

- Considers how mixing water with a felt-tipped pen could be used to create different effects.
- Alternates between using water, felt-tipped pens and diluted paint to create a unique mixed-media 'painting'.

Inspiration

- Look at examples of watercolour painting such as *Summer* by Hans Heysen (1909). Note the ways some colours are well defined while others flow together.
- Allow the students to make dots on the art paper using each felt-tipped pen. Add water to each dot and watch the colours disperse and reveal the base colours that make up each colour.

Instructions

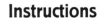

Step 1

Prepare an area of newspaper to work on. Use felt-tipped pens to draw the trunks of several trees. The trunks should start approximately one-third of the way up the page. Some should be younger trees or saplings while others should be well advanced. Some should start higher on the page to give the illusion of distance. Do not colour the trees. Rather, create texture on each trunk by drawing a series of irregular vertical lines and elliptical 'knots'. Add individually drawn leaves to the branches and upper margin of the page. Several sparsely spaced horizontal lines in green and blue can be added to the bottom of the page to represent a creek and its shoreline. The shoreline should be drawn in several disjointed line segments.

Step 2

Paint the lower third of the page with water or simply dip the page into water up to the creek's shoreline. The felt-tip markings will blur and run to create a 'liquid' impression. While the paper is still very wet, use a felt-tipped pen the same colour as the trees to draw a reflection for each trunk in the water. The trunks will blur and run as they are drawn to create a muted reflection in the creek. Repeat this process for any other detail, such as leaves.

Step 3

When the painting is dry, mix solutions of diluted yellow and orange paint. Paint the solution between the trees, being careful not to 'bleed' any colours unnecessarily in the top section of the picture, to create a sunset sky for a background.

Felt-tip watercolour

Step 4

Allow the painting to dry. Add any small details or redefine areas blurred accidentally during the painting process using felt-tipped pen. When satisfied with the finished painting, mount it on a 'muted' or wood-grain style background consistent with the intensity of colour in the artwork.

Reflection questions

- How did the felt-tipped pens react with water?
- Were you able to produce some pleasing effects by adding water to your felt-tipped pen drawing? Describe some of them.
- What 'atmosphere' did you create using a watercolour effect? How would you describe the colours? Strong? Weak? What other kinds of images would suit 'water colours'?

Variations

- Transform acrylic paints into crude 'watercolours' by adding different quantities of water, making some into 'washes' while others remain more vibrant for finer detail.
- Paint on absorbent paper using coloured edicol dyes. Use a fine-tipped paintbrush for fine detail and a wide flat brush to create 'washes'.
- Add dry powder paints to a wet surface and, using a wet brush or sponge, mix the paint on the wet paper into a watery image.

Cross-curricular activities

- Review the many roles water plays in keeping things alive.
- Research a natural disaster involving water; for example, tsunami, flood, mud slide, drought or cyclones.
- Visit the facility supplying water to your community. Investigate associated water treatment plants, drainage and pollution.
- Promote water-wise practices such as washing cars on the lawn, having shorter showers with water-wise nozzles and using 'half-flush' on the toilet cistern to reduce unnecessary water wastage.

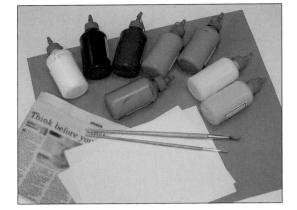

Resources
- all paint colours
- thick and thin brushes
- white paper
- newspaper
- card for mounting

Indications:

Skills, techniques, technologies and processes

- Applies paint in layers to achieve an image with depth.
- Uses brushes of different size and shape to create blocks of colour or fine detail.

Responding, reflecting on and evaluating visual arts

- Understands that impressionist images are built from blocks of colour.
- Evaluates own work and adds colour and detail to achieve depth and interest on a base of colour blocks.

Inspiration

- Discuss what is meant by a landscape. Look at examples of traditional landscapes.
- Encourage the students to be original in the image they choose to reproduce. It need not be a complete landscape – perhaps just a small section closer up.
- Look at an image with squinted eyes and identify the 'blocks' of colour that make it up.

Instructions

Step 1

To create this painting, either find an image such as a landscape photo to copy, use a real landscape for inspiration or simply work from memory to create an original landscape. Consider the types of landscapes that could be created; for example, desert, ice scape, forest, or coastal. By squinting at an image, it is easier to identify blocks of colour and dark and light areas. Identify where these colour blocks are in the image you wish to recreate and their proximity to one another. Using a wide paintbrush, mix the appropriate colours and paint the colour blocks onto a sheet of art paper.

Step 2

Using a medium-sized brush, add tints and shades to the colour blocks to give them depth and develop an 'atmosphere' within your painting. The colours used to add this detail and their location will begin to give an illusion of a particular time of day or climatic conditions.

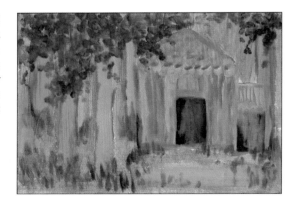

Step 3

Using a fine paintbrush, add 'information' to the drawing, detailed in the foreground and less defined in the background or distance if a wider angle has been taken. Take time to step back from the painting and add as you see fit to create the image you desire. Paint over sections if you are unhappy and rework them to develop an image you are pleased with.

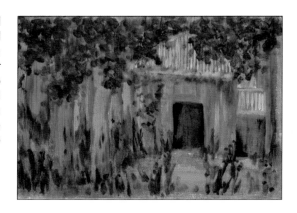

Country shack

Step 4

Allow the painting to dry and mount the landscape in a traditional 'timber-look' frame. A cardboard mount can be treated by painting lines of brown edicol dye over a timber grain pattern drawn in felt-tipped pen.

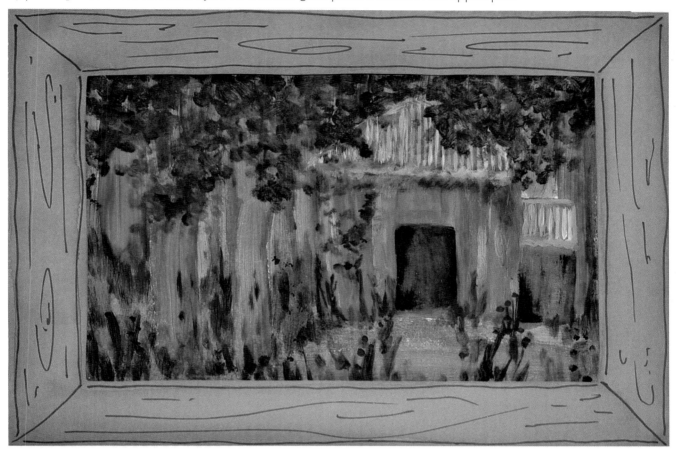

Reflection questions

- What image did you choose to reproduce? Why did you choose this image?
- Were the colour blocks easy to identify? Did you find identifying and painting the colour blocks the easiest or most difficult part of the process?
- Did you paint shadows in the correct place? Where is the light coming from in your picture?
- Was much detail required to define the image you reproduced? Would you describe your painting as impressionistic or realistic?

Variations

- Create impressionist paintings using only geometric blocks of colour.
- Create a collage using blocks of coloured fabric scraps. Add smaller collage pieces to create detail.
- Closely study the colours and shadows of a person's face. Paint a portrait using colour blocks to depict those colours and shadows.

Cross-curricular activities

- Brainstorm to create a list of environments. List habitats that exist within each of those environments to demonstrate ecological diversity.
- Expand numbers and identify how they can be broken in a number of different ways into smaller parts.
- Use simple building blocks to construct a self-supporting bridge.
- Identify different elements in the classroom. Discuss the way atoms combine as the building blocks to create those elements.

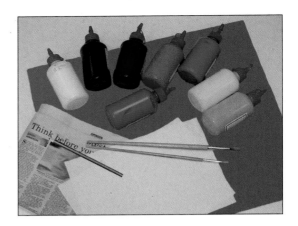

Resources

- purple card for mounting
- white paper
- all paint colours/felt-tipped pens
- thick and thin paintbrushes
- newspaper
- palettes
- pencil

Indications:

Skills, techniques, technologies and processes

- Investigates and practises the techniques used by famous artists.
- Applies the techniques of others to original artwork.

Responding, reflecting on and evaluating visual arts

- Takes inspiration from the painting *The scream* by Edvard Munch to create an original artwork.

Inspiration

- Look at a picture of the painting *The scream* by Edvard Munch (1893). Discuss the emotions created in the viewer by looking at the painting. Discuss how the person in the painting must be feeling. What is he/she screaming about? Discuss what the painter is trying to tell the viewer through his painting.
- Brainstorm other powerful emotions that could be conveyed through a facial expression.

Instructions

Step 1

Look at people with surprised expressions. Note the shape of their eyes, mouth, nose and eyebrows. Consider the way a face changes shape with a surprised expression. Do the cheeks become higher? Does the chin become flatter or pointier? Imagine a surprised face in your mind and attempt to replicate it as an outline onto a large sheet of art paper. Accentuate the face by adding concentric lines inside and outside the shapes of the face. Refer to the way lines have been used to express fear on the face of the person in the painting *The scream* by Edvard Munch. Attempt to apply this technique to accentuate 'surprise' in your image.

Step 2

Prepare an area of newspaper on which to work. Think about the colours that are representative of 'surprise'. Put these colours onto a palette. Paint the 'lines' of your design inside the person's face using predominantly unmixed colours next to each other.

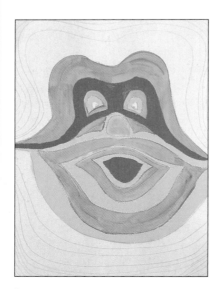

Step 3

To make the face stand out, paint colours around the outside, increasingly dark as they get closer to the edge of the page. Add purple or similar colour to the palette. Continue painting the 'lines' around the outside of the face, working from the lightest unmixed colour through to the darkest colour introduced. Lines that accidentally mix at the edges with the adjacent colour will add to the colour gradient and can look effective if not overdone.

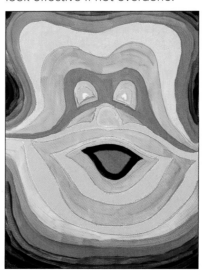

'Surprise' portrait

Step 4

Allow the painting to dry and add detail to the eyes and other facial features using a fine-tipped paintbrush or felt-tipped pens if desired. Mount in a frame the same colour as the dark colour introduced in Step 3. Add a caption, *The surprise*, written in marking pen on foil.

Reflection questions

- What emotions were you trying to convey to the viewer of your painting?
- What do you think your subject is feeling? Why is he/she surprised?
- Is your surprise a 'good' surprise or a 'bad' surprise? How do the colours you chose reflect this?
- Are you trying to tell the viewer something through your painting? What would you like the viewer to understand from it?

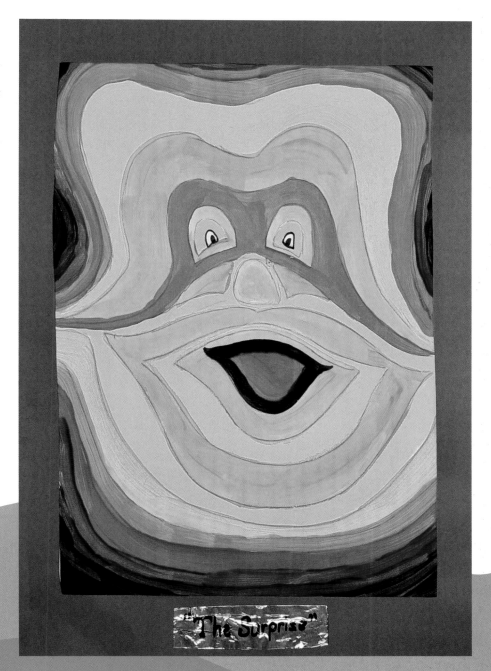

Variations

- Use the same or a similar technique to create other powerful expressions of emotion.
- Blend the colours together more fluidly so that the striping is not so distinct. Add dark facial grooves to give the face more depth.
- Apply the technique to the face of an animal, such as a dog or cat.

Cross-curricular activities

- Write a short story or recount a personal event in which someone receives a surprise.
- Read amazing facts from record books.
- Play games where a number of tall stories are told and only one is true. Have the students guess which one they think is true and justify their reasons for thinking so.
- Challenge the students to plan and deliver a surprise to a chosen class member.

Glossary – Painting

abstract	idealistic, not practical, free from representational qualities
analogous colours	closely related colours such as red, red-orange and orange
camouflage	a kind of disguise, either natural or human-made that makes something hard to see among its surroundings
complementary	colours occurring opposite on the colour wheel
cubism	the reduction of natural or actual things to a geometric basis
diluted	make thinner or weaker by adding water
edicol	dye created from natural products, often in the form of powder
ellipse	regular oval
exotic	attractively strange or unusual
impressionism	a 19th century style in which artists attempted to paint the fleeting effects of natural light with bright pure colours of the spectrum
landscape	(a) a painting of country scenery (b) horizontal layout of rectangular page
morph	change from one subject to another through a gradual distortion
mute	tone down
portrait	(a) a painting, drawing or photograph of someone, especially of his/her face (b) rectangular paper placed vertically
proximity	nearness
sketch	a drawing or painting done roughly or quickly
still life	the depiction of lifeless things such as ornaments, fruit and musical instruments
surrealism	'super-realism' or 'beyond realism'; often fantastic dream-world compositions of detailed realistic objects
tonal gradation	the gradual progression from light to dark
subject	something chosen by an artist for painting

Useful websites

Artists and movements

The Metropolitan Museum of Art	www.metmuseum.org
Impressionism	www.impressionism.org/
Surrealism	www.mcs.csuhayward.edu/~malek/Surrealism/
Art Museum network	www.amn.org
Cubism	abstractart.20m.com/cubism/htm
Still Life – Pierre Bonnard	www.artofeurope.com/bonnard/bon5.htm
Art in context	www.artincontext.org/index.html
Watercolour – Jean Haines	www.jeanhaines.com/
Edvard Munch	www.edvard~munch.com/

Tools and techniques

Watercolour tips	website.lineone.net/~peter.saw/tips.html

Art education

Art education and ArtEdventures	www.sandford-artedventures.com
The artroom	www.arts.ufl.edu/art/rt_room

PRINTMAKING

Indications:

Skills, techniques, technologies and processes

- Draws a design comprised of closed shapes.
- Uses a craft knife to cut clean lines and remove closed shapes to create a template.
- Uses a sponge to print through a paper template.

Responding, reflecting on and evaluating visual arts

- Attempts to create closed shapes from open shapes by breaking them into parts.
- Attempts to visualise a print from its template and makes adjustments if required.

Inspiration

- Look at a variety of posters used for advertising. Choose posters that have been screen printed or stencilled to share.
- Note the way pictures have been broken into shapes suitable for stencilling.
- Brainstorm subjects for printing using stencils which have obviously segmented parts and demonstrate what a stencil design for that subject might look like.

Resources

- orange card for mounting
- craft knife
- pencil
- sponge
- tray
- newspaper
- white paper
- paint in primary and secondary colours
- lithograph paper
- cutting board
- sharp scissors

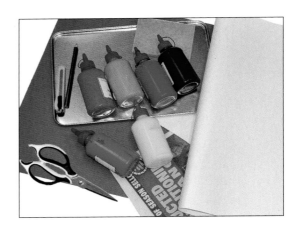

Instructions

Step 1

Choose a subject for a template. The design will need to be composed of closed shapes. Think about how your subject could be broken down using a series of shapes to describe it. Draw your design in pencil onto the shiny side of a sheet of lithograph paper. Check that there are no shapes within shapes. If there are, add narrow tabs to join these pieces to the template.

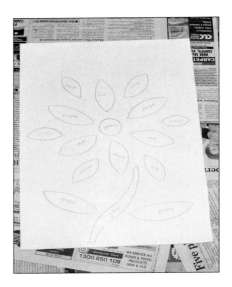

Step 2

Place the lithograph paper with the design on top of a firm cutting board. Do not use corrugated boxing cardboard or a similar soft surface as the knife will not cut cleanly and may leave ragged edges. Use a sharp knife to make clean careful cuts and remove the closed shapes to create your template. (Adult supervision may be required for this activity.) Tidy up any ragged areas with sharp scissors if necessary. Tidy edges reduce the chance of paint 'bleeding' during the printing process.

Step 3

Prepare a work area with newspaper or plastic sheeting. Ensure the students are wearing protective clothing. Lie the template on top of a white sheet of paper. Pour small amounts of each paint colour to be used onto a tray. Load the corner of a sponge with the paint colour to be applied first. Hold the template firmly in position and gently blot through the desired shape without wiping.

Sponge stencils

Step 4

While the template is still in position, blot each of the remaining shapes with the appropriate coloured paint. Be sure to wash out the sponge or use several different sponges to ensure the colours do not mix and become 'muddy'. Carefully remove the template from the print while the paint is still wet. Allow the print to dry and mount to display.

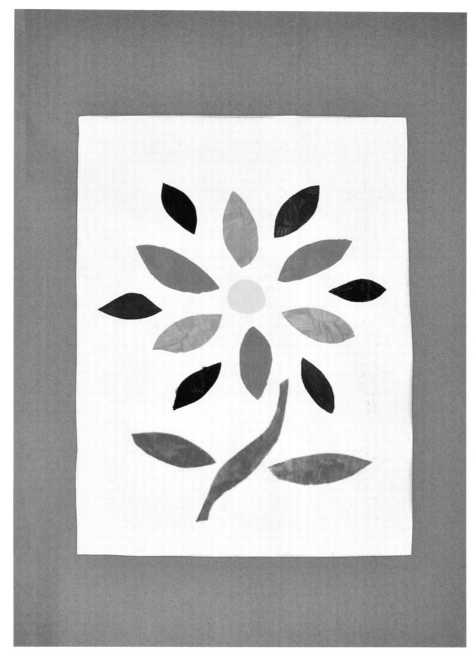

Reflection questions

- How intricate was your design? Did you find it difficult to cut out?
- Did your stencil print well? Was there 'bleeding' at the edges? Why do you think some stencils bleed? How could bleeding be avoided?
- What colours did you choose to print with? Did they help make your print eye-catching?

Variations

- The students can take a magazine picture and trace shapes within it to be cut away, creating the picture in stencil form. Ensure the students create closed shapes only.
- Stencil names to print onto school books.
- Make stencils to promote a candidate for class captain.
- Print signs or logos using stencils.

Cross-curricular activities

- Incorporate your stencil print into a holiday brochure and write descriptive passages to describe the chosen location.
- Discuss tactics used by advertisers to sell or promote their products.
- Complete operations using whole numbers composed of many parts.
- Investigate percentage as parts of a whole.

Resources

- pale blue textured paper (optional)
- blue and white paint in squirt bottles
- paintbrush
- black fine-tipped pen
- glitter
- aluminium foil
- strong glue
- liquid starch
- newspaper
- silver and black card for mounting

Indications:

Skills, techniques, technologies and processes

- Creates a background or 'environment' for an artwork by creating a blot print.
- Makes appropriate multimedia additions to transform a blot print into a recognisable image.

Responding, reflecting on and evaluating visual arts

- Decides what additions are needed to make a flat blot print into an 'environment'.
- Uses symmetry in the environment as inspiration for his/her own artwork.

Inspiration

- Watch videos or look at stimulus pictures of Antarctica or other icy landscapes. Note the colours in the ice and the way water reflects icebergs.
- Look at images that show a reflection in water.
- Create a simple 3-D model and use direct lighting to cast shadows and create reflections on still water.

Instructions

Step 1

Prepare a work area with newspaper or plastic sheeting. Ensure the students are wearing protective clothing. Squirt small amounts of white and blue paint in irregular lines across a sheet of paper. (Textured papers may be used. These will add to an Antarctic atmosphere and create a slight contrast to the white paint.)

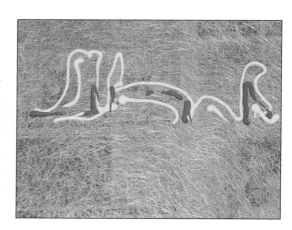

Step 2

Fold the paper in half lengthways while the paint is still wet to create a symmetrical blot print. One half of the print will represent icebergs above the water. The other half will represent their reflection in still water. Allow the print to dry in a flat position.

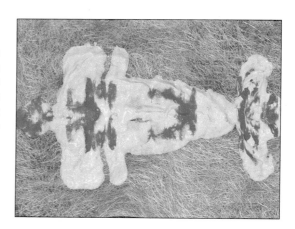

Step 3

Paint liquid starch over the bottom half of the print and sprinkle thickly with glitter to create reflective water. Glue tiny crumpled foil balls onto the top half of the print to create stars in the sky

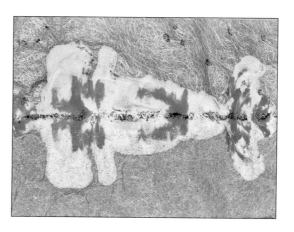

Antarctic print

Step 4

Use a fine-tipped black pen to draw in details such as tiny penguins on the iceberg. Draw their reflections using disjointed lines to create their mirror image in the water. Mount the print on silver card against a black background.

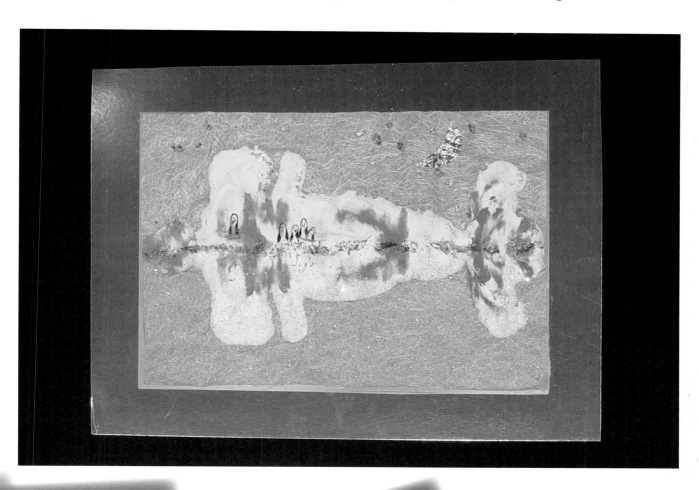

Reflection questions

- What did you do to try to capture an Antarctic atmosphere?
- What time of day do you think your print represents?
- Do your icebergs look realistic? Could you or did you add anything to the print to enhance the image?
- Does your print look cold? Why?
- What colour card would best display your print?

Variations

- Depict other environments where reflections are made; for example, quiet streams, wharfs or jetties. Students attempt to create an atmosphere that describes a particular time of day using folding prints.
- Create a cave by painting stalagmites and fold it in half to create printed stalactites from them.

Cross-curricular activities

- Research life in hostile environments such as Antarctica.
- Investigate and measure the displacement of water by different volumes of ice.
- Predict what might happen to existing land masses if the polar ice caps were to melt.
- Investigate environmental issues such as the greenhouse effect, what has caused it, and its potential impact upon the earth.

Resources

- lino square
- carving tools
- black marking pen
- lead pencil
- hard roller
- tray
- black paint
- black card for mounting
- white paper
- newspaper

Indications:

Skills, techniques, technologies and processes

- Draws a simple image onto a lino square.
- Uses cutting tools to carve a design out of a lino square.
- Uses a hard roller to apply paint to a lino square to make a print.

Responding, reflecting on and evaluating visual arts

- Understands that a lino print produces a mirror image and draws his/her design accordingly.
- Assesses the success of the print based on self-generated criteria.

Inspiration

- Look at icons used at past Olympic Games to represent different sports.
- Demonstrate printing with a lino square with writing. Note that the image and writing will print in reverse.
- Allow the students to experiment using carving tools on scrap lino prior to carving their final tile.

Instructions

Step 1

Think about the Olympic icon design you wish to create. What sport will you represent? What should the icon look like? Will it be symmetrical? Consider that when the lino is printed it will create a mirrored image. Draw your design onto the lino tile in reverse. Alternatively, draw a design that is symmetrical. Use a black marking pen to colour all the areas you will be carving away. Think about what you want to print black and what you want to leave as unprinted white paper. Any areas cut away will remain white after printing.

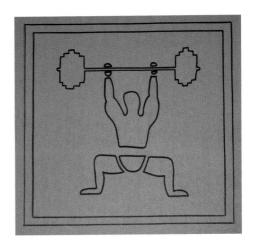

Step 2

Using carving tools, carve away the areas coloured black. This activity requires adult supervision. Take care to always cut away from the hand holding the tile to avoid injury.

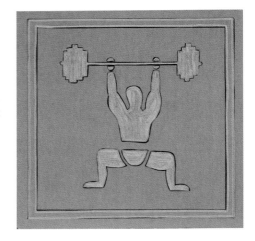

Step 3

Prepare a work area with newspaper or plastic sheeting. Ensure the students are wearing protective clothing. Pour black paint onto a tray and use a hard roller to spread it evenly, so that an even amount of paint is picked up by the roller. Roll the paint across the lino tile so that a thin, even coating of paint is applied to all parts of the tile. Turn the lino tile over and print onto a piece of white paper. Use a clean hard roller to roll firmly across the back of the tile so that all parts of the lino tile come into contact with the paper. Carefully peel away the lino tile to reveal the print.

Lino print icon

Step 4

Make several prints with the lino tile. If smudging occurs, clean the areas of the tile where it is 'bleeding' after each print and apply less paint for subsequent printmaking. Mount the icon against a black background.

Reflection questions

- Does your lino print represent the sport you intended? What features make your icon distinctive from other sports?
- Did you make a clean print? How does the amount of paint affect the quality of the print?
- What difficulties did you encounter when carving the lino?
- How did you overcome these difficulties?
- Were you pleased with your final design?

Variations

- Carve a design into a lino tile that can be printed end to end to create a continuous pattern.
- Print silhouettes in black over paper prepainted with several sunset colours.
- Encourage the students to texture sections of the lino using lines, dashes or spots.
- Attempt to carve a drawing using lines and sections of solid shaded colour to show perspective.

Cross-curricular activities

- Create shadow puppets to make silhouettes for telling a story.
- Find out about the mascots of the most recent Olympic Games. What do they represent? What mascot would you design to represent your country?
- List Olympic sports. Research the history of one of them.
- Survey favourite Olympic sports or events.
- Map the route of the Olympic flame.

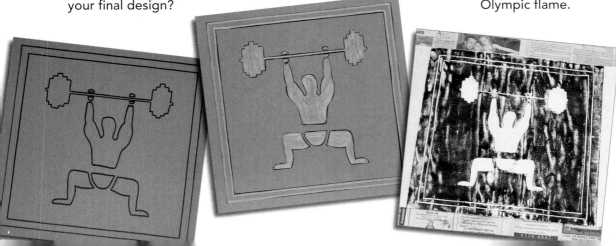

Resources

- silk-screen
- squeegee
- lithograph paper
- scissors
- craft knife
- pencil
- yellow fluorescent paint
- newspaper
- white paper
- special paper (optional)

Indications:

Skills, techniques, technologies and processes

- Draws a design comprised of closed shapes.
- Uses a craft knife to cut clean lines and remove closed shapes to create a template.
- Uses a silk-screen to print through a paper template.

Responding, reflecting on and evaluating visual arts

- Develops a technique for connecting 'floating' internal shapes to the template.
- Assesses each print and makes adjustments in order to improve the quality of each print.

Inspiration

- Make a list of occasions where rewards should be given. Suggest a suitable image to represent each.
- Look at the silhouettes created by light behind a subject. Note that there is no shading, only solid colour.
- Demonstrate how an image can be transformed into a stencil for a single colour to be printed.

Instructions

Step 1

Invent an award for the students in your class to strive towards. Consider that screen-printing will allow you to reproduce your award many times. Draw your award design onto the shiny side of a sheet of lithograph paper. Be sure that the design for your template will fit inside the boundaries of the screen you will be using. Each letter you 'write' will need to take the form of a closed shape for printing. Where there are 'floating' internal shapes, add small tabs or 'bridges' to connect these shapes to the template.

Step 2

Place the lithograph paper with your design on top of a firm cutting board. Do not use corrugated cardboard or a similar soft surface as the knife will not cut cleanly and may leave ragged edges. Use a sharp knife to make clean careful cuts and remove the closed shapes drawn. (Adult supervision is required for this activity.) Tidy up any ragged areas with sharp scissors if necessary. Tidy edges reduce the chance of paint 'bleeding' during the printing process.

Step 3

Place the template shiny side up on top of the paper you wish to print on. Place the silk-screen on top of the template and paper. The screen should be flush against the template. Pour paint along the top edge of the screen. Ask a second person to hold the screen firmly in place. Use a squeegee to drag the paint across the screen surface and push the paint through to the paper. Enough pressure should be applied to the squeegee for it to flex while dragging the paint. Several uses of the squeegee may be required for the entire surface to become covered in paint. However, the more times the squeegee runs over the surface, the greater the opportunity for the paint to 'bleed'. Carefully lift the screen to reveal the printed page.

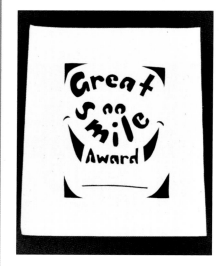

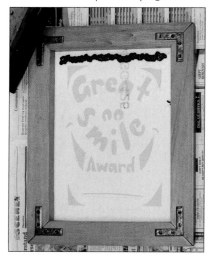

Screen-print award

Step 4

Several prints can be taken while the screen's design is intact. If bleeding occurs, blot the area gently with a tissue to remove excess paint. If necessary, apply small amounts of masking tape to repair ragged edges. Make prints on special 'award' paper and, when dry, present to worthy class members.

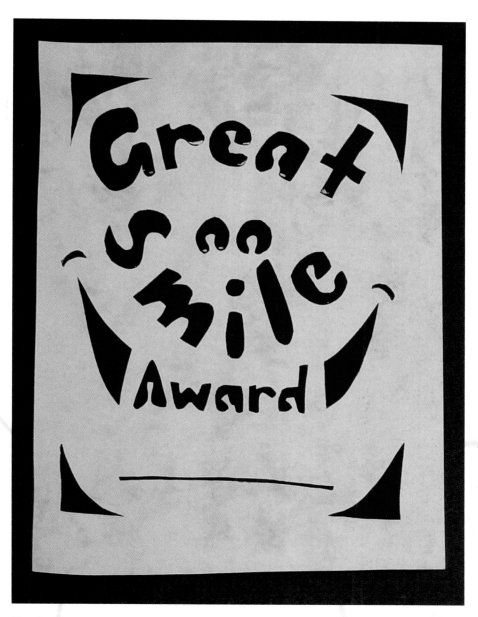

Reflection questions

- Was it a simple task to cut out your stencil? What bits were tricky?
- How did you stencil letters with internal spaces? Why are these shapes a problem when making stencils?
- How else could you have created a reproducible award certificate?
- What is your certificate awarded for? What image did you use to depict this award?
- What colour combinations of paint and paper will look most effective?

Variations

- Screen-print words, logos or signs to advertise an event.
- Draw or copy an image and use a thick marker pen to make shapes that could be cut away to make a stencil for a screen-print.
- Cut away stencils of skeletons or veins on leaves to make abstract screen-print images.
- Print onto prepainted paper in appropriate colours and patterns.

Cross-curricular activities

- Enter writing or maths competitions.
- Research a winner of the Nobel Peace Prize.
- Read award-winning books.
- Imagine being the winner of a specified award. Make impromptu acceptance speeches to the class.
- Award class members for various worthy achievements.
- Make up a funny award for each of your peers.

Resources

- white paper
- metal skewer/kebab skewer/toothpicks
- white paint
- pencil
- dark blue paper
- gold card for mounting
- gold glitter
- sponge or fine-tipped paintbrush
- newspaper
- scissors
- black fine-tipped pen
- black marking pen

Indications:

Skills, techniques, technologies and processes

- Creates a constellation design from a familiar subject.
- Prints through a stencil comprised of tiny holes.

Responding, reflecting on and evaluating visual arts

- Chooses a subject with a distinctive structure suitable for transforming into a constellation.
- Determines the success of the technique used and suggests ways it could be refined during future printmaking.

Inspiration

- Look at a night sky or pictures of constellation patterns.
- Compare the illumination of a night sky with a full moon to one with a new moon.
- Students attempt to 'map' a section of the night sky themselves.
- Provide the students with constellation maps to help them identify famous constellations.

Instructions

Step 1

Choose a subject with a distinctive shape. Imagine the shape's outline as a series of dots or 'stars'. Think about whether or not the subject will still be recognizable as a series of dots or 'constellation'. Draw the outline of the subject very lightly on a sheet of white art paper. Use a black marking pen to mark the intersecting points of the outline. These dots or 'stars' will be brighter than the others. Use a fine-tipped black pen to mark other smaller stars in between the bright stars along the outline of your subject.

Step 2

Use a metal skewer, kebab skewer or toothpicks to press through the paper at each marked dot to create small holes. This will be done most successfully on a soft background, such as carpet, polystyrene or corrugated box cardboard. Make the bigger stars by wiggling the skewer to widen the hole.

Step 3

Prepare a work area with newspaper or plastic sheeting. Ensure the students are wearing protective clothing. Pour white paint onto a tray. Place the constellation stencil on top of a sheet of dark blue paper or card. Use a sponge to dab paint through each of the holes in the stencil so that a tiny amount of paint prints through to the dark surface to the 'stars' of the 'constellation' you designed. If the sponge does not seem to penetrate well enough, a fine-tipped paintbrush may prove more effective.

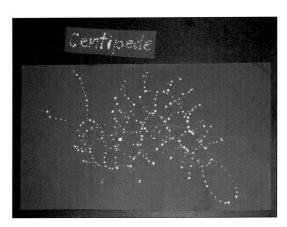

Constellation print

Step 4

While the print is still wet, sprinkle with gold glitter and allow it to dry. When the print is dry, shake off any excess glitter and mount against a gold background. Make a plaque naming your constellation. The constellation's name can be included in the print itself and this part of the stencil used to print the plaque.

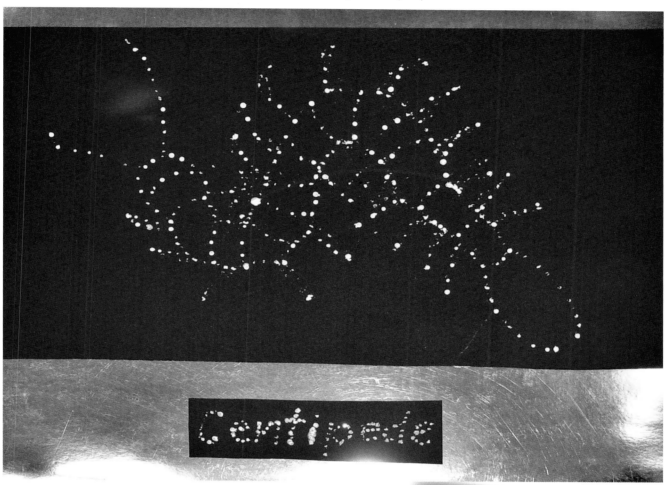

Reflection questions

- Were your stars clear in your print? How could you ensure they would print clearly?
- Is your print very luminous? How did you achieve this look?
- Did you print a real constellation? Or is it your own design? What did you name your constellation?
- Does your constellation stand out from the other stars?

Variations

- Use 'pinholes' to create lines which describe a picture or pattern such as a flower outline.
- Place a leaf over a piece of paper or card and use pinholes to trace the outline, veins and any distinguishing features.
- Use pinholes to write words.
- Use pinholes in combination with stencilled shapes to 'shade' an area of a print.

Cross-curricular activities

- Investigate the latest developments in space research and the role played by NASA.
- Research the history of space travel.
- Compare the planets and their capacity to support life.
- Use the Internet to discover the latest in Mars exploration.
- Discuss the concept of stars as suns and develop an understanding of the enormity of the universe.

Resources
- heavy card
- white paper
- brown, blue and green paint
- sponge
- tray
- scissors
- Blu-Tack®
- newspaper
- pencil
- green card for mounting

Indications:

Skills, techniques, technologies and processes
- Draws and cuts out a template of shapes depicting a tree trunk.
- Uses cardboard templates to print a series of adjacent colours.

Responding, reflecting on and evaluating visual arts
- Discusses the benefits and disadvantages of using a cardboard template for printmaking.
- Discusses the inspiration behind the shapes and colours chosen to depict the tree trunk.

Inspiration
- Challenge the students to find an interesting or unusual section of bark on a tree. Allow time to make a sketch of the bark and note the variations in colour.
- Demonstrate the printing process for a 'floating' stencil. Students discuss and sequence the colour printing in a logical manner.

Instructions

Step 1

Draw a tree trunk onto a piece of moderately heavy card using lead pencil. The card should be heavy enough to hold its shape but flexible enough to cut out with scissors. Divide the trunk itself into several shapes to describe the texture of the bark. Use strong scissors to cut out the shapes, being careful to arrange the pieces back together like a jigsaw as you go.

Step 2

Prepare a work area with newspaper or plastic sheeting. Ensure the students are wearing protective clothing. Pour the coloured paint chosen for the tree trunk onto a tray. Lie the cardboard template directly on top of the paper to be printed. Think about what colours will be used across the print. Which pieces will be the same colour? Make a plan for what colour and when you will print each piece in sequence. Load a sponge with paint and dab it onto the underside of one of the pieces. Return it to its position so that it prints in its exact place. The cardboard template can stay on the sheet to help line up where the other pieces will go. However, printed pieces must be removed well before the paint has dried to avoid sticking and tearing.

Step 3

Mix the new colours one at a time and print the remaining pieces according to the sequence you planned. Remove printed cards as soon as they are no longer required to help line up subsequent prints. Paint the remaining area around the stencil green.

Tree bark print

Step 4

Allow the completed print to dry. Mount against a 'forest' coloured background in keeping with the colours you chose for the bark of your print.

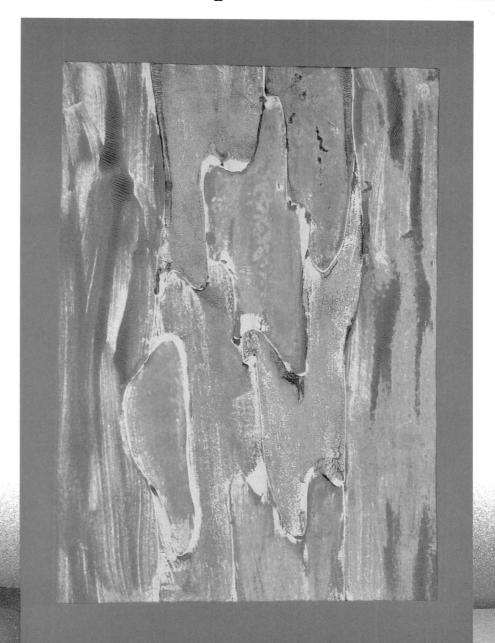

Reflection questions

- How many pieces did you include in your floating stencil? How many colours did you use? Did you find this manageable?
- Did you create a tidy print? What difficulties did you need to overcome in the printing process?
- Was your print a reasonable interpretation of a tree trunk?
- Were you pleased with the quality and image produced by your printing?

Variations

- Make a collage of a tree trunk, using fabric scraps to represent the variations in colour and texture.
- Make rubbings of natural surfaces.
- Use floating templates or stencils to 'airbrush' a design using spray paints, or by flicking a toothbrush loaded with paint.
- Make drawings of tree trunk cross-sections using a concentric pattern and analogous colours.

Cross-curricular activities

- Investigate the roles played by trees from environmental and economical viewpoints.
- Research sustainable logging practices and mark old growth forests on a map.
- Write arguments for and against the logging of old growth forests.
- Study the rings on a cross-section of a tree trunk. Identify features such as periods of drought or rain from the width and colour of the rings. Track the life and establish the age of the tree.

Indications:

Skills, techniques, technologies and processes

- Uses textured collage materials to represent different surfaces on a building.
- Applies paint evenly to a textured surface and makes a print.

Responding, reflecting on and evaluating visual arts

- Assesses the effectiveness of different textures as a printmaking surface.
- Appreciates the variations in patterns that can be achieved by printing a raised collage surface.

Inspiration

- Collect a variety of textured materials such as corrugated card, sandpaper and polystyrene packing beads.
- Look at older style buildings with corrugated iron roofs and stone walls. Students suggest materials to make a collage that has a similar texture to these building materials.
- Make prints of many textured materials as a reference for constructing the final collage for printing.

Resources

- collage materials
- strong glue
- heavy card
- white paper
- hard roller
- soft roller
- paintbrush
- paint in primary and secondary colours
- newspaper
- tray
- brown card for mounting
- lead pencil
- scissors

Instructions

Step 1

Make a line drawing of a building or house, composed of a number of different textures, onto heavy card. Buildings that include stones, timber and other natural building materials produce the most striking results.

Step 2

Use a variety of collage materials to represent the line drawing in blocks of texture. For example, use corrugated card for a corrugated iron roof or bubble wrap for a stone wall. Cut the collage materials into appropriately-sized shapes to fit the picture. Place each of the pieces on top of the drawing in their designated spot. Add details such as trees, rocky ground or even a bird in the sky. When satisfied with the completed picture, glue each of the pieces using strong glue.

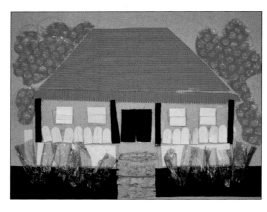

Step 3

Prepare a work area with newspaper or plastic sheeting. Ensure the students are wearing protective clothing. Pour an 'earthy' coloured paint onto a tray and use a soft roller to pick up the paint evenly. Use the roller to apply paint to the collage, making sure that surface is well coated. Alternatively, use a paint brush to paint several different colours onto the collage to make a coloured print. Turn the collage over and place it carefully face down onto the blank sheet of paper. Hold the collage in position and use a hard roller to roll firmly over the back of the cardboard collage mount. Make sure all parts of the collage have been rolled and as much of the collage texture has come into contact with the paper as possible.

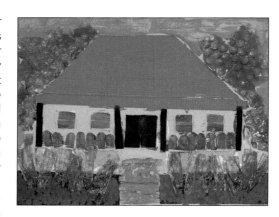

Texture print

Step 4

Carefully lift the collage away from the paper to reveal the texture print. Mount against a rustic colour in keeping with the natural materials in the print.

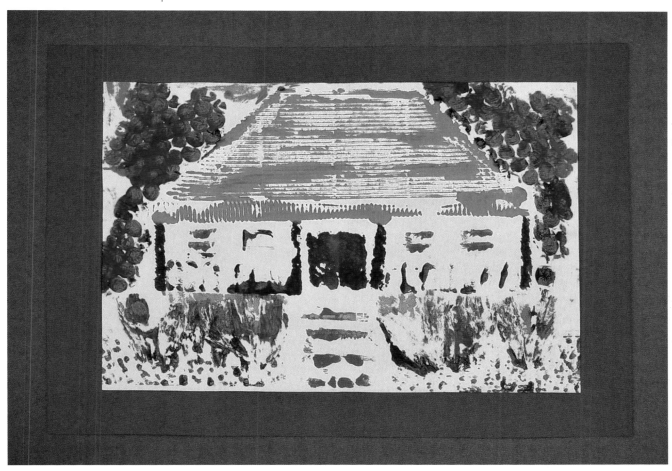

Reflection questions

- Did each of the collage materials print equally well? Which were more effective? For which could you have chosen a better alternative?
- What type of building did you print? What distinguishing features do these buildings have? How did you try to create an impression of these features?
- Are you happy with the final impression you made?

Variations

- Make a collage of leaves, flowers and natural fibres such as hessian to make an environmentally-friendly print.
- Glue collage materials such as leaves or real feathers in the shape of a bird.
- Use synthetic materials such as polystyrene packing beads, string and carpet scraps to create patterns or pictures.
- Print from a seaside collage constructed from objects such as sand, shells, driftwood, netting and seaweed.

Cross-curricular activities

- Investigate the latest innovations in building. Note the materials used, climate appropriateness and environmentally-friendly inventions.
- Draw floor plans of a dream home to scale on squared paper.
- Investigate the properties of different building materials. Develop a way of testing each for durability in a variety of climatic conditions.

Indications:

Skills, techniques, technologies and processes

- Forms clay into a satisfactory roller shape.
- Etches a continuous design into a clay roller.
- Makes a continuous print using a print roller.

Responding, reflecting on and evaluating visual arts

- Understands that a roller will produce a continuous print.
- Creates a design to take advantage of the continuous nature of a roller print.

Inspiration

- Brainstorm things that create tracks or trails. Discuss the difference between repetitive and cyclical patterns.
- Provide the students with scrap paper to develop and design a linear, continuous pattern.
- Brainstorm linear things.
- Discuss how the circumference of the cylinder used will affect the length of the pattern.

Resources

- clay
- etching tools
- paint
- red card for mounting
- tray
- white paper
- newspaper
- craft stick
- modelling boards
- scrap paper

Instructions

Step 1

Prepare a work area with newspaper or plastic sheeting. Ensure the students are wearing protective clothing. Provide the students with clay modelling equipment, including modelling boards (a heavy board covered in calico works well and will absorb excess moisture in the clay and prevent the clay sticking to the work surface) and etching tools. Etching tools can be the commercially produced variety or simply toothpicks or even old sharpened pencils. Roll a piece of clay into a cylinder shape. Thread a craft stick through the length of the cylinder so that a small 'handle' protrudes from either end. Smooth the surface and edges using the fingertips. Roll again to achieve an even surface.

Step 2

Select an etching tool and etch a design into the surface of the clay. Consider what type of print would look effective in a continuous pattern. The lines need to be deep enough to create a recess between the remaining flat surfaces of clay. Once complete, clean away any excess clay scraps and lightly roll the etched clay across a flat surface to remove any unwanted 'bumps'.

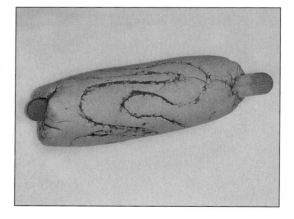

Step 3

Pour one or two coloured paints onto a tray. Roll the clay roller through the paint so that the print surface is completely covered. Roll the roller across a sheet of scrap paper to remove excess paint. Roll the clay roller across a sheet of blank paper. Repeat the printing process to cover the page or create a border as planned.

Clay roller print

Step 4

Allow the print to dry. Mount on coloured card. The roller can be used several times and its print image remodelled while the clay is still pliable. Alternatively, the roller can be fired or simply dried and kept as a resource for creating borders for future work.

Reflection questions

- Is your pattern continuous? Does it create a linear pattern which flows? Would you change your pattern if you were to repeat the activity?
- How would you describe your pattern? What was your inspiration?
- Were you pleased with the quality of your print? How did your print alter with each revolution?

Variations

- Etch patterns such as snakeskin, rope or tyre tread onto a roller for printing.
- Cut sections out of a cheap foam roller to create a pattern for rolling.
- Glue textured scraps onto a cardboard cylinder and use to print wrapping paper. Used rolled prints to create borders for classroom displays.

Cross-curricular activities

- Find repetitive patterns in numbers. Find missing numbers or extend number patterns.
- Use trundle wheels to measure long distances.
- Find the circumference of circles given their radius.
- Compare tyre treads and hypothesise why some would grip the road better than others.
- Brainstorm to make a list of things that are cyclical.

Resources

- wood or thick cardboard block
- sponges
- black marking pen
- pink, red and purple fluorescent paint
- purple card for mounting
- tray
- newspaper
- strong glue
- white paper
- scissors
- hard roller

Indications:

Skills, techniques, technologies and processes

- Uses sponges to create a raised surface for printing.
- Makes a print using a print block.

Responding, reflecting on and evaluating visual arts

- Recognises other types of block printing and compares them to his/her own.
- Assesses the visual impact of his/her own print.

Inspiration

- Look at a picture of a mushroom. Discuss how an image of a single colour could be printed. What technique could be used?
- Demonstrate how the mushroom can be broken into parts to define its shape better in a print.
- Allow the students to draw simple images and then cut them into shapes in order to describe their internal lines.

Instructions

Step 1

Choose a subject to describe through a print. Draw the subject onto flat sponges using a marking pen. Break the subject up into shapes at internal lines; for example, a mushroom cap and its stalk. This will help to define the shapes better when they are printed by leaving an unprinted line where internal lines have been drawn. Cut out the sponge pieces. Note that prints will be in reverse using this technique.

Step 2

Lay the sponge pieces in a design on the cardboard 'block'. Arrange and rearrange the pieces until you are happy with the way it looks. You may need to add other details to the design to give it more character or to balance it. Glue the pieces in their designated places and allow time to dry.

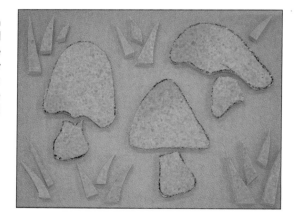

Step 3

Prepare a work area with newspaper or plastic sheeting. Ensure the students are wearing protective clothing. Pour two or three coloured paints onto a tray. Use a hard roller to join and mix the edges of the colours to create a 'rainbow' effect. Press the print block surface into the paint so that only the sponge comes in contact with it. Press the print block onto a sheet of blank paper. Carefully remove the print block to reveal the printed image. Repeat a number of times. Allow to dry.

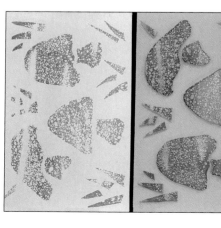

Block and sponge prints

Step 4

The print block can be used many times, washed and dried and kept as a resource for future printmaking activities. Select the best print and mount against one of the rainbow colours you used.

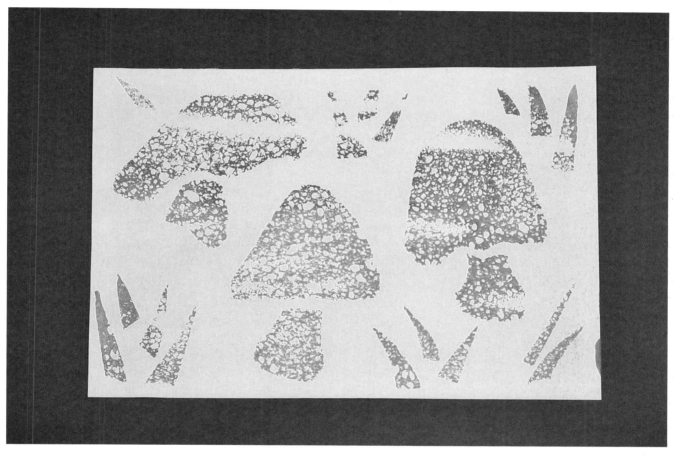

Reflection questions

- What subject did you choose to describe?
- How did you go about breaking up your shape? Do you think you chose appropriate places in your subject to create breaks?
- Did your print turn out cleanly? How did you make sure of this in the printing process?
- Would you use this printing technique again? Why?

Variations

- Cut simple shapes from thick sponges and use them to make a repetitive or random pattern.
- Glue sponge shapes onto a cardboard roller to create a continuous print.
- Make a sponge block of your name or a personal logo to print onto books or envelopes.

Cross-curricular activities

- Investigate objects that are porous, such as sponges, pumice stones and fabrics. Test other objects and materials to find out whether they are porous.
- Compare the infiltration rates of different soil types. Discuss the effects of irrigation on these different soil types.
- Write a procedure for a favourite or invented printmaking process.

Resources

- burgundy card for mounting
- liquid starch
- tray
- different coloured acrylic paints in squirt bottles
- greaseproof paper
- newspaper
- fork, comb or knife

Indications:

Skills, techniques, technologies and processes

- Uses a marbling technique to create unusual printed patterns.
- Experiments with different paper surfaces to create a translucent effect.

Responding, reflecting on and evaluating visual arts

- Understands that 'marbling' can be achieved using a variety of different techniques.
- Suggests possible applications for 'marbled' papers.

Inspiration

- Look at examples of marbling including marbled papers and fabrics and surfaces such as those found in kitchens and bathrooms. Discuss the differences in the intensity of the colours.
- Use the Internet to research the different techniques used to create a marbling effect.
- Brainstorm possible uses for fabrics or papers that have been marbled.

Instructions

Step 1

Prepare a work area with newspaper or plastic sheeting. Ensure the students are wearing protective clothing. Prepare liquid starch and allow to cool prior to the activity. Directions for making liquid starch can be found on page x. Pour the cooled liquid starch into a shallow tray. Make sure the tray is large enough for your paper to fit across its surface. Drop or squirt coloured paints onto the surface of the liquid starch.

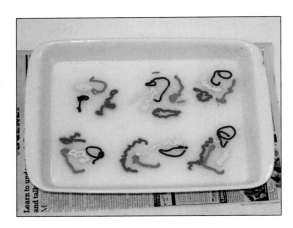

Step 2

Use a fork, comb or knife to create a flowing marbling design in the paint on the surface of the liquid starch.

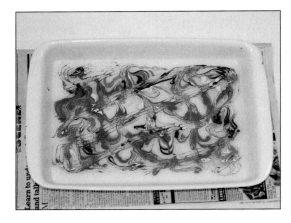

Step 3

Fill a sink or basin with cold water to create a 'bath' for printed papers. Carefully place a piece of greaseproof paper flat onto the swirly paint surface. Lift the paper out of the tray and place into the water 'bath' to remove any excess starch. This needs to be done swiftly. Note that smaller pieces of paper will maintain the most 'traditional' marbled images. Larger sheets will tend to 'run'. Allow the print to dry.

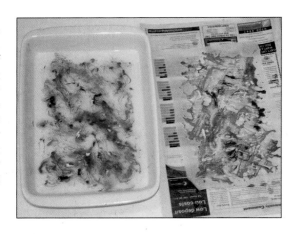

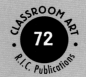

Marbling

Step 4

Repeat the process, making several marbled prints. Experiment with different types of paper and compare the strength of the colours produced. When the prints have dried they can be mounted for display or cut into sections or shapes and used to decorate greeting cards.

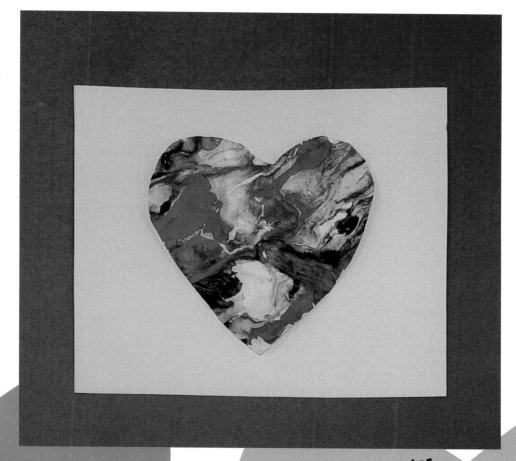

Reflection questions

- What colours did you choose to use for your marbling?
- Did you plan the type of pattern you wanted to create? What inspired you to pursue that type of pattern?
- Were you able to 'swirl' the paints in the liquid starch to create the pattern you anticipated?
- Was your marbling effort a success? Did you repeat the process to refine it? What changes did you or would you make before further printmaking?

Variations

- Add alum to a water bath to create a suspended surface in place of liquid starch. Add dyes to the suspension to create a vivid marbled print.
- Print the marbled surface onto other types of paper, including heavy tissue paper or art paper.
- Paint the surface of a sheet of art paper with a solution of icing sugar and water. Drop paint onto the wet surface and mix gently with a paintbrush in a swirling pattern to create a marbled effect.

Cross-curricular activities

- Build a class rock collection. Start the collection with a piece of marble and compare the patterns on its surface to those created when marbling paper.
- Investigate how marble and other minerals are extracted from the ground.
- Design and play a new game using marbles and hold a class marble competition.

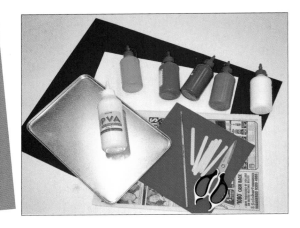

Resources

- craft sticks
- green, blue, purple and pink fluorescent paint, white paint
- coloured paper squares
- fine-tipped paintbrush
- tray
- newspaper
- royal blue card for mounting
- scissors
- glue

Indications:

Skills, techniques, technologies and processes

- Makes different types of prints using craft sticks.
- Combines the making of a collage with printmaking to produce a familiar image.

Responding, reflecting on and evaluating visual arts

- Refines a printmaking technique in order to produce a desired effect.
- Combines printed shapes with collage shapes to produce a complete image.

Inspiration

- Look at pictures of peacocks and other exotic birds. Note in particular the vibrant colours of a peacock's tail feathers and the manner in which it displays them.
- Experiment with a craft stick to see what different prints can be made with it.
- Isolate the key colours that are unique to the peacock and layer them along the length of the craft stick to identify an effective combination.

Instructions

Step 1

Prepare a work area with newspaper or plastic sheeting. Ensure the students are wearing protective clothing. Pour small amounts of green, blue and purple paint, one above the other, onto a tray or palette so that the three colours sit next to each other without mixing. Combine them but ensure that they are no longer than a craft stick. Dip the edge of a craft stick into the paint so that all three paint colours coat the edge of it. Purple at the top, blue in the middle and green at the bottom. Carefully lift the craft stick out of the paint and use it to make a printed line on a blank sheet of paper. The craft stick can be moved slightly using the bottom end as an anchor to form a tiny arc. Repeat this process so that a series of these tiny arcs combine to create a semicircle, each print representing the feather in a peacock's tail. Make several peacock tails across the page using the same technique. Allow the prints to dry.

Step 2

Cut out a body shape for each of the peacocks from coloured paper squares. The shape should resemble a teardrop with a circular head at the top.

Step 3

Attach the bodies to the printed peacock tails and use a fine-tipped paintbrush and paint, or coloured paper scraps, to add other details, such as beaks, legs and head plumes. Pour a small amount of pink or purple paint onto a palette or tray and dip the end of a craft stick in the paint. Make a small print at the top of each tail feather by placing the tip of the craft stick at the end of each feather and rolling it to create small, semicircular marks.

Craft stick prints

Step 4

Cut out each peacock, with a scalloped cut around the tail feathers. Mount against a royal blue background.

Reflection questions

- What colours did you identify as the main descriptors of a peacock?
- Did you use these colours in your print? How did you layer them?
- Describe how you created the prints for each tail feather.
- How did you go about transforming your print into a recognisable image of a peacock?

Variations

- Load a thick paintbrush with three different paints. This can be done by dipping the brush in paint and washing out two-thirds of the bristles. Dip the brush into a second colour up to the first colour and wash out half the second colour leaving one-third of the bristles for the third colour. Make several prints with the brush before washing it out and starting again.
- Use craft stick prints to create echidna or porcupine spines, cactus spikes or the struts of a tower.

Cross-curricular activities

- Research birds with elaborate plumage. Find out what purpose their bright feathers serve.
- Bird feathers are a renewable resource. Brainstorm and discuss ways they could be substituted for non-renewable resources.
- Build a class collection of bird feathers and attempt to identify the birds from which they came.
- Go on a 'bird spotting' expedition to become familiar with local bird life.

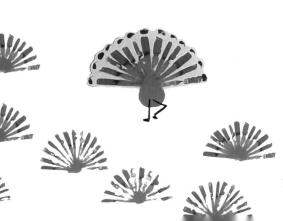

Resources

- candle
- matches
- white art paper
- coloured paper
- pastels
- newspaper
- pencil
- card for mounting

Indications:

Skills, techniques, technologies and processes

- Attempts to control the dripping of wax to create lines and shapes suitable for rubbing.
- Uses pastels to make a rubbing of an irregular waxy surface.

Responding, reflecting on and evaluating visual arts

- Assesses the suitability of his/her print design for wax rubbing and suggests alternatives.
- Chooses colours that complement a coloured paper 'canvas'.

Inspiration

- Students explore textured surfaces with the pads of their fingers while wearing a blindfold. Challenge them to identify the surface they are feeling.
- Demonstrate how to hold a candle so that it melts the wax rapidly enough to drip onto a paper surface to create a texture.
- Brainstorm the names of creatures with knobbly skin suitable for creating a print from wax drippings.

Instructions

Step 1

Draw a simple design onto a piece of white art paper or light card. The paper will need to be thick enough to support the impact of the hot wax that will be dripped onto the surface.

Step 2

Prepare a work area with newspaper or plastic sheeting. Ensure the students are wearing protective clothing and are in a well-ventilated, closely supervised environment. Light a candle and hold it upside down so that the flame melts the wax quickly, causing it to drip onto the page. Attempt to control the flow and drips of the candle wax onto the page by holding it close to the page. Trace over the lines drawn in the design with the dripping wax. If large areas of wax have been created, patterns can also be etched into them using a toothpick or a sharp pencil.

Step 3

Allow the wax to cool into a solid state. Place a sheet of coloured paper over the surface of the waxy design and using coloured pastels, rub over the surface to show the indentations of the surface and reveal the design.

Melted wax rubbing starfish

Step 4

Pastel drawings and rubbings can be sealed to avoid smudging using a commercially produced fixant spray. Choose one of the pastel colours used in the artwork to make a striking mount for display.

Reflection questions
- What difficulties did you encounter making your wax rubbing? Can you think of any way you could have made it easier?
- What medium did you choose to rub your wax with? Why did you choose this medium? Do you think you made a good choice?
- Does your final rubbing look like the design you drew in wax? What could you do to enhance it?

Variations
- Make rubbings on brightly coloured paper using charcoal.
- Enhance rubbings by using felt-tipped pens to outline or accentuate certain lines or shapes. Add materials to rubbings to create a 3-D effect. For example, make rubbings of fruit and glue on materials for leaves.
- Rub interesting vegetables, leaves, clothing or manufactured objects such as coins or calculators to make a unique collage of prints.

Cross-curricular activities
- Investigate where wax comes from and how it is made into candles.
- Follow a procedure to make simple candles.
- Discuss fire safety and conduct a practice evacuation drill.
- Discuss and list uses for fire. Construct a simple time line to show how our uses of fire have changed.
- Students write a dramatic story about a wildfire.

Glossary – Printmaking

air brush	device for spraying paint by means of compressed air
bleed	a term used to describe the manner in which a liquid medium spreads
block print	a print produced from a pattern which has been etched into or built onto a wooden block
canvas	heavy cotton cloth that can be used for painting, usually stretched across a wooden frame
corrugated	wrinkled or folded material with strongly formed ridges
craft knife	cutting knife
cross-section	transverse section of an object or drawing; for example, the circular surface created when a carrot is cut in half
greaseproof paper	paper often used in baking with a waxed repellent surface
illumination	lit up, made bright
lino tile	square tile cut from linoleum for the purpose of printmaking
lithograph paper	paper produced for the purpose of printmaking with one smooth, ink-repellent surface and the other surface absorbent
multimedia	composition of more than one media type; for example, a painting with a collage glued on
rubbing	reproduced patterns or designs created by rubbing paper laid over a surface with a soft medium such as chalk
silk-screen	silk stretched across a wooden frame to form a fine gauze through which to print
squeegee	flexible flat-edged tool used for spreading painting in an even consistency
stencil	thin sheet of paper or other material in which lettering or other designs are cut out
symmetry	the arrangement of the parts of something so that they are all balanced in size and shape about some central line
template	a precut cardboard design used as a guide for drawing or cutting out a closed shape
watercolour	paint made of pigment diluted with water and not oil; a painting done in watercolour

Useful websites

Artists and movements

The Museum of Modern Art	www.moma.org
Andy Warhol and Van Gogh	www.artmuseum.net
The worldwide art gallery	www.theartgallery.com.au
Etchings of Rembrandt	www.artrembrandt.com/
Textiles	www.museumfortextiles.on.ca/

Tools and techniques

Dictionary of printmaking	www.philaprintshop.com/diction.html
Colour museum	www.sdc.org.uk/museum/mus.html
ArtLex on collage	www.artlex.com/ArtLex/collage.html
The art of marbling	members.aol.com/marbling/marbling/

Art education

The incredible art department	www.princetonol.com/groups/iad/